Ex libris David J. Patten

PRINT COLLECTING

PRINT COLLECTING

Silvie Turner

Lyons & Burford, Publishers

Printed in the United States of America

10 9 8 7 6 5 4 3 2 1

Design by Fleuron / Holly A. Block

Library of Congress Cataloging-in-Publication Data

Turner, Silvie, 1946–
 Print collecting / Silvie Turner.
 p. cm.
 Includes bibliographical references and index.
 ISBN 1-55821-366-X (cloth). — ISBN 1-55821-507-7 (pbk.)
 1. Prints—Collectors and collecting. I. Title.

 NE885.T87 1996
 769ʻ. 12—dc20 96-22094
 CIP

Contents

Acknowledgments

One of the great passions in my life is for prints and printmaking. I also love to document—to lay down information for storing and dipping into—part of which is searching and researching, and I have had much delight collecting for this book. I send grateful thanks to all those who helped me and who so willingly allowed me to dip into their accumulated knowledge and experience.

Special thanks to Ken Tyler of Tyler Graphics, New York, for his helpful comments on the manuscript.

Print A mark left on a surface by something that has been pressed against it; an impression left on paper, etc.

Collecting Assembling, accumulating, bringing or coming together, gathering, regaining control of

Photo by Howard Jeffs. Photo courtesy Tony Wilson

An etching plate receiving a final hand wipe before printing.

Introduction

Prints have become a familiar and pleasurable element of modern culture—broadening the audience for art and challenging artists to experiment with both traditional and innovative techniques. Printmaking is a demanding and complex medium, involving not only the unpredictability of the creative process but also, hand in hand, the technical mastery of a skill. Prints are manifestations of activities as diverse and inventive as those involved in any art medium.

I have always looked upon collecting itself as a creative act. The joy of looking and finding is part of being creative, and certainly for me possession is undeniably part of enjoying any work of art. There is something wonderful and unique in owning an original print that I have chosen and bought—a sense of adventure and of satisfaction as slowly, on closer acquaintance, the work reveals more and more of itself.

The past ten years have seen an extension in the field of collecting the work of living artists. I have learned that collecting contemporary work is a complicated affair that includes the uncertainty and adventure of buying possible unrecognised masters. My own collections are based on what I like, which—I hasten to add—has changed considerably over time. (I began collecting at that early, impoverished-art-student age by buying a Hockney for £7, cleaning it, and selling it three days later for £10.)

If you have bought a print, you are a collector. Some collections can be formed overnight; others can take up much of a lifetime. Today, making a collection can offer such excitement: the possibility of travel; opportunity to learn; the chance to respect new attitudes, see different perspectives, look at the creativity of others, even understand and become involved in the development of an individual artist. Making a collection is an opportunity, a treasure to be valued. When I look at the prints I have bought, I often re-experience the moment of buying each addition. I see acquiring a print as not only an independent act but also one that demonstrates my evolving tastes—even insights. I feast myself on the subtle characteristics and details that probably can only be

recognised by my own individual taste. It is often a revelation to me exactly what my personal taste allows me to buy. Quite often, when I am hanging or rehanging, I find myself startled by what I see and have not seen before—an illumination of some previously unperceived likeness, information, or relationship in the works I have acquired.

Taste and collections evolve together, building upon one another; their parameters are indeed unique and personal. Yet collecting prints at this particular time in history has its advantages and its pitfalls. Many collectors will already have experienced the dramatic rise and fall in market prices during the last decade. Although we are now in a period fairly realistic prices, the age of extraordinary leaps is not over—art-world excitement and fashion still have enormous influence on prices.

This is a book about collecting prints for anyone with a special interest in contemporary prints—a sort of "owner's manual" for print collecting. I have written factually and in a straightforward, common-sense way about issues I have encountered. My intention has been to make the basic tenets of this art form readily accessible to anyone—those who are new to it as well as those who are generally interested in acquiring information. I hope it offers a comprehensive and appropriate introduction to contemporary print collecting. Although the text has been deliberately kept as simple as possible, this is not a book that I envisage can be read from cover to cover. It is to be used when you most want it—to gain confidence, to become able to identify the occasionally mystifying processes that are encompassed by the term *printmaking*. It probably does not contain anything new for the print historian, for it is restricted to prints of the Western world and includes as many contemporary developments as possible.

It is probably true that there are those who learn by reading, and there are those who rely on intuition and learn by trial and error. Although experimentation is probably the most disadvantageous way for a professional to build a collection, I encourage everyone to look at and search out prints in any way they like—and to take advice from this volume by dipping into it whenever necessary.

PRINT COLLECTING

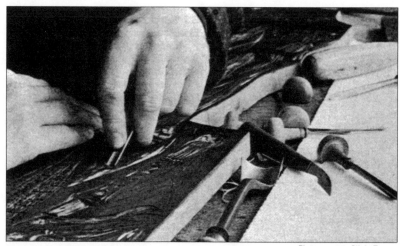

A wood block and wood cutting and engraving tools.

What Are Original Prints?

Original prints are increasingly regarded as examples of a major art form. Today, more interest is centred on the print than could have been predicted even twenty years ago. New developments are continually taking place and it is in the field of original prints that some of the most important and innovative works have been created—certainly in the last few decades, some might even say in this century.

There are opportunities as never before for artists to make and sell their prints. The possibility of copies of a print being released simultaneously in many parts of the world at the same time gives this art form the immediacy of mass communications media.

Despite this increased awareness, a blurring of the very separate and distinct guidelines separating the print not only from other forms of art, but also from each of the separate printmaking processes, has occurred. The twentieth-century artist is continually extending his horizons and experimenting with new ways of making art, defining and redefining it.

GUIDELINES ON ORIGINALITY

The whole question of whether or not a print is an original work is a comparatively new one. Although many of the best-known works by some of the world's greatest artists are prints—think of Dürer and

■　3

Rembrandt—I have often found it surprising that so little is generally known about the medium. Few people know the difference between an etching and lithograph, let alone an engraving or a drypoint, and defining an experimental new technique or mixed media print often becomes a major problem.

I believe that is necessary to have a basic knowledge of the artist's process to even begin to appreciate his/her intention or achievement in a particular medium. Therefore a clear idea of what a print is is necessary from the outset.

An original print is, in essence, an image that has been produced by a process that enables it to be multiplied; or—as it is often described— an essential feature of a print is its ability to be produced in multiple copies.

How Can This Be an Original Work If More Than One Copy Is Produced?

It is sometimes held that a print is a "secondary" object compared with, for instance, a drawing or painting because it is simply a copy of a drawing onto a block of wood, a plate, or a stone that is then printed or reproduced. The latter is not an original print. Printmaking's unique possibilities, arising from the interaction between the artist and the medium, can produce beautiful aesthetic effects unrealizable in any other way. Thus, great prints of the world are not reproduced drawings but works of art in their own right created through the medium of print-making. An original print is a finished composition and an end product of an artist's creative process; in this respect, it could easily be said to stand closer to a painting or sculpture than a drawing. An original print, however, does utilise a medium that allows more than one copy to be produced. It therefore has been confused with the many other results arising from the duplication of images via any printing method.

A look at the term *original*

Before the invention of photography, every printed block, stone, or plate was prepared by hand, therefore we cannot use "made by hand" as a factor in determining originality (although in many definitions by various bodies, it plays a key role).

In past centuries, prints that were handmade were generally called

engravings. Later, the term lithograph was also widely used to describe almost any print. They were often referred to generically as simply prints until the distinction arose between creative graphic art (produced as early as the late fifteenth century by such artists as Dürer, Rembrandt, and Canaletto) and imitative reproductions such as those made by the craftsmen who copied original paintings. Both kinds of work were called prints and were considered genuine, but the creative kind—produced by artists and often judged on a level with paintings—is what we are discussing here.

A principal distinction we must make is between the reproductive and the nonreproductive. A reproductive print reproduces a work created in a different medium (for example, an engraving "after" a painting). Before photography, the demand for this sort of work was enormous and generations of expert reproductive engravers were trained to satisfy the demand. Occasionally, the medium was taken up by creative artists themselves, who were attracted to the range of possibilities and effects that could be achieved only with engraving. Prints made by artists in this manner were in no way reproductive, and the artists were often called painter-engravers, painter-etchers, and so on. They were creative and their works were, in a sense, the opposite of reproductive.

Various inventions effected the production of all types of prints. One was the automised printing press, whose products replaced handmade reproductive prints. Another fundamental change came with the invention of photography in the 1820s. The methods and technological developments using the photograph that occurred so quickly (and have continued to this day) affected printing greatly, and the range of techniques for producing printed matter grew enormously. It is probably true to say that this new photomechanical technology managed (and continues to manage) to confuse the public's mind about the status of an artist's print—and also to devalue it as an art object.

How should we distinguish—and in what terms—these two classes of printing? The term *original* (as opposed to *photo* or *photomechanical*) began to be used in the 1800s, but this also has its difficulties. This idea of originality is also often confused with that of singularity—one of a kind. Yet in defining an "original" print we grasp at both of the concepts.

The terms *print* and *printed* in themselves are also confusing, because they can be used to describe a host of different items—a snapshot, a newspaper, a fabric, a poster, and so on. Thus the terms *printmaking* or *original graphics* or *graphics* are used to describe original prints in an attempt to identify the nonreproductive.

Limited editions

Another invention—credited to the American artist James Whistler—that allowed a distinction to be made between original and reproductive prints was the limiting of editions. Whistler created suites of monoprints from one etching plate that suggested different moods by painterly surface tone. This helped establish what has been called from that time the original print; in Whistler's day, the term meant that the concept, the making of the plate, and the printing of all the sheets was accomplished by one and the same man. Eventually, it became usual to sign each work in pencil and serialise the prints, artificially limiting the edition by canceling the plate at a predetermined number. All this conferred a uniqueness upon the prints, which Whistler then compounded in the late 1880s by issuing signed lithographs with wide margins for twice the price of an identical image on smaller paper. Thus the signing and limiting of the original, fine artist's work in the print medium began.

In an attempt to help the public distinguish between original printmaking and photomechanical reproduction, various committees were set up—particularly in this century—to provide simple definitions of an original print. Listed below are some of the confusions that arose as the definitions were pounded out, often in terms of the actual processes. In 1960, about the same time that some of the bodies were attempting to determine the characteristics of the original print and reach a precise definition, another confusing dilemma arose: Artists began to find photomechanical processes of interest and to use them in their work. (Such prints, of course, remain original, because the photomechanical processes are not being used to make facsimiles of already existing artworks.)

Guidelines on originality from 1960 onward

The Third International Congress of Plastic Arts (IAPA) in Vienna in 1960 drew up definitive guidelines for the original print—possibly as a result more of international trading and import taxes than of the desire to protect the collector. The IAPA committee, composed only of artists, issued a recommendation indicating, in essence, that an original print must be printed from plates, blocks, or stones made by the artist himself; must be signed and numbered; and its printing matrix must be canceled after the edition.

This was followed in 1961 by guidelines from The Print Council

of America, which substantially modified the terms of the Vienna definition.

1. The artist alone has created the master image in or upon the plate, stone, wood, block, or other material for the purpose of making the print.

2. The print is made from the said material by the artists according to his directions.

3. The finished product is approved by the artist.

The group allowed most modern printmaking techniques with the exception of direct photography and "exclusive reliance on photo-mechanical plates," which, it said, "were frowned upon by most printmakers."

In December 1964, the Comité National de la Gravure in France added its own initiatives to the guidelines, dictating that original prints must be "conceived and executed entirely by hand by the same artists . . . with the exclusion of any and all mechanical or photo-mechanical processes." The tradition of French artists collaborating with experienced master printers appeared to be totally ignored. Both definitions excluded screenprints.

Import regulations and taxes in many countries added to the confusion. In Britain, prior to the introduction of the Value Added Tax in 1973, legislation allowed printed "art" of an arbitrary edition size of seventy-five (or even the first seventy-five of a larger edition) to constitute an original print and be exempt from tax, while "reproductions" (anything over seventy-five copies) were subject to a heavy "fancy goods" tax. Canada classified etchings, lithographs, and relief prints as "fine art" but disallowed screenprints, which were taxed.

More recently, in 1990, the Conseil Québécois de l'Éstampe published its own thorough code of ethics for defining the original print, identifying that Québécois printmakers up to the late 1960s adopted what it termed a "mother-European tradition" by assuming responsibility for all stages of production from concept to matrix fabrication to printing.

In London, between 1992 and 1995, attempts were made by a committee comprised of members from many boards of trades, associations, and guilds to set a "British Standard" ("BSI") classification of prints. The document was eventually drawn up by Joseph Winkelman,

then president of the Royal Society of Painter-Printmakers, and Professor Pat Gilmour. They believed that the only way forward from the impossibility of drawing up simple definitions in the light of "amazing new advances in modern technology" was to set out some guidelines to educate the public and thereby provide a form of consumer protection. The guidelines were based on categories of prints listed from A to G, each with its own definition—from A, which "denotes that the artist alone created the matrix and made the impressions from it," to F, which "denotes that the print has been made without the permission of the artist or the artist's agent." Category G denotes that "a matrix has been used for print . . . reprinted without the artist's knowledge." Additional clauses concerning signatures, numbering, value, plate marks, restrikes, and so on were laid out clearly. A brave attempt, which has not yet been accepted as a standard.

Several states in America have adopted legislation that requires the "truth labeling fine prints" (applying only to prints made after the law came into force). The Trades Descriptions Act in Britain makes it more difficult for the public to be deliberately misled, but the imprecise nature of many of its terms still leaves loopholes.

To add to this long debate, recent innovations in printmaking have to some extent confused the issue of what physically constitutes a print. The traditional idea of a print is a flat, inked image on paper. However, many contemporary prints are three-dimensional or have objects incorporated into them. A number of processes, for instance, involve no ink at all; in addition, artists have used commercial reproduction, computer, fax, and even laser and ink-jet techniques. All have helped to blur definitions even further.

What we can arrive at with certainty is that the definition of a print, like that of any other art medium, is in a fairly constant state of debate and evolution. The various definitions, as I see it, reflect the social and aesthetic needs of a given society and even the individual expression of a particular artist. So a collector would be advised to look to the artist, publisher, or gallery to provide the fullest information on which judgment could be based.

Although I have reached the conclusion that constructing a simple definition encompassing all countries' contributions, and all the techniques used by artists, is impossible, I have attempted below to list my own guidelines for those readers who may require it.

The basic definition that I would put forward: An original print is simply a work conceived by an artist for the print medium alone;

printed by the artist, or under his supervision and meeting his requirements; and approved by him, with his signature on the finished work.

Below, I have identified some of the issues concerning the inherent nature of an original print. Although various terms exist for "original print"—print, graphic print, graphics, fine-art print—in this context I will retain the clearest description, "an original print."

1. An original print is essentially associated with the integral participation of the artist in the process.

2. The originality of the print is firmly based in the artist being the author of the concept of the work involved in the process of realising the printing matrix—regardless of the nature of that process.

3. The artist finally approves the work by signing the print. The signature of the print by the artist confirms the artist's approval. (It does not, however, guarantee authenticity or originality, because some artists also consent to sign reproductions and posters.)

4. An original print is an original multiple made by a process in which there are not one but many originals.

5. An original print is distinguished from a reproduction, facsimile, or such by the artist's direct involvement in the exploitation and manipulation of one or more of the printmaking processes, of which the result is either a series, an edition of prints, or a unique work.

Acceptable variations on the above include:

1. That the original print is not printed by the artist but under his supervision.

2. That the edition was printed on more than one paper type.

3. That the original print may have been signed in the plate or stone.

4. That the edition was not dated or titled.

5. That the original print exists as an unlimited edition (multiple).

6. That print documentation is signed by the artist and printer/publisher, and is available.

Not acceptable in terms of the above guidelines:

1. That the original print is not signed.

2. That the original print is wholly or photomechanically a reproduction of an image in another medium.

3. That the original print was signed prior to printing.

4. That the print is an unauthorised impression from an original matrix.

MORE INFORMATION ON COPIES AND FORGERIES

Defining a copy or a reproduction is also contentious. It is necessary that copies or reproductions be acknowledged and equally important that they be distinguished beyond question from original prints.

One of the greatest confusions for the buying public is the situation in which living artists allow others to make "prints" from completed originals without exercising any control. By agreeing to sign a reproduction, limiting the number printed—for example, to a few thousand—simply confuses the issues and can cause a reproduction that might have cost a few dollars to rocket up unbelievably into a price of two or three figures. Because of situations like these, reproductions have quite unjustifiably acquired a bad name. Legislators, particularly in the United States, have tried to protect the consumer with laws requiring dealers to reveal the exact nature of a technician's or copyist's work, but these laws have proven difficult to enact.

The earliest "fakes" were simple piracies; some of the most famous were Marcantio's copies from Dürer. True fakes only arose with the advent of the collector. These were sometimes exact copies masquerading as originals (especially of Dürer and Rembrandt), and sometimes pastiches in a master's style. The invention of photomechanical reproduction processes produced a new type of fake—the reproduction printed on a sheet of old paper. Falsifications are, however, more dangerous and deceptive than outright fakes—damaged originals can be so thoroughly repaired as to go far beyond any legiti-

mate restoration. Another type of falsification is to turn a later print into an earlier, more desirable one.

A fake is a copy of a work from an original, and is often made by "artists" undisputedly brilliant and creative in their own right. Most early prints were copies of originals and intended to be reproductions rather than forgeries. True forgeries of prints—the deliberate attempt to pass off an unauthorised impression as the real thing—are a fairly recent phenomenon. In a suspected forgery, it is essential that the print be examined by a trained expert who can compare the dubious work to originals.

It is sometimes the case today that photomechanical reproductions of drawings and paintings published as "original prints" possess such technical mastery that it is impossible to identify the photomechanical process with the naked eye. Applying known guidelines, such cases (along the lines of a reproduction being an attempt to copy an existing image, often in another medium) are often quite difficult. In many cases, a buyer simply has to rely on the seller to give accurate information concerning the work. When you buy a print, the gallery or dealer must be able to answer all of your questions—otherwise it is wise to assume that it or he cannot evaluate the work properly either.

Another type of reproduction is termed "faux graphique," which is an image made by hand in the style of an artist with or without the artist's consent—but not by the artist's own hand.

A collector may well prefer to buy an original print from a reputable source and pay more for it than to purchase a work from a stranger or inexperienced dealer. A print that has been catalogued by experts, or whose history has been verified by connoisseurs, is a more secure investment. Occasionally a certificate of originality, identifying all aspects of the work, is given with a sale.

In detecting forgeries, nothing can replace long years of experience looking at and being involved with original prints. Even magnifying glasses, photo enlargements, and laboratory analysis—which all play their part—cannot replace experience and knowledge.

A lithographic stone and test print.

How Is a
Print Made?

There are many ways to make meaningful and wonderful prints. The term *printmaking* encompasses myriad processes and techniques, and their number is continually enlarging. Artists all over the world use this medium, which ranges from making the simplest print from a potato or linocut to complex prints utilising many different media—intaglio, lithography, photo-work, computer-generated imagery. Some prints defy classification altogether.

The Process of Printing

Printing is the term used for the transfer of an original image, usually with ink, onto paper or another support. The parts of the original that must be produced in ink are called the image areas. The uninked portions are called the nonimage areas.

The common denominator of all printing processes is the printing image carrier—that is, the surface on which the image and the non-image areas are clearly defined. This is often called the matrix (or block, plate, screen, and so on).

The printing process is usually divided into three steps:

1. The preparation of the image carrier (matrix), on which the image areas are separated from the non-image areas.

2. The application of ink to the matrix.

3. The transfer of ink onto paper or other support under pressure.

Grouping of printmaking techniques

The majority of prints are described by the process with which they are made. At present, there appear to be two fairly distinct groupings of prints—those made with the so-called traditional media and those made with nontraditional or very innovative media. The traditional techniques (which account for by far the greatest numbers of works being made) can be divided into four major categories: relief processes, intaglio processes, lithographic (or planographic) processes, and stencil processes (identified by many as the second planographic process). "Planographic" indicates simply that the print has been made from a flat-surfaced matrix. These four major groups are described below.

THE RELIEF PRINT

The relief process is probably one of the oldest techniques in printmaking; it was already in existence toward the end of the fourteenth century.

Relief printing exploits the surface characteristics of any material. Traditionally, these characteristics have resulted from manipulation of a surface such as wood or linoleum by engraving, cutting, abrading, or scoring. A revival of the relief technique came with Gauguin and Munch in the 1880s; their work in turn inspired the artists who formed the group Die Brücke in Dresden in 1905—Kirchner, Heckel, Nolde. Their aggressive hacking into the wood can now be seen as a point of departure for the twentieth-century woodcut revival. This has continued with artists such as Michael Rothenstein in England and Leonard Baskin in America.

During the 1960s, a new enthusiasm for relief spread, particularly over Britain and the United States, in which the emphasis was put on the inclusion of natural or found surfaces such as heavily eroded wood or metal, fur coats, tires, and hands. These were used as the matrices from which to obtain an image. A wider approach led to surface recording by offset printing or casting in latex, as well as to assemblage, the use of mechanical or electrical power-cutting tools or computer-aided cutting devices, and so on.

In all relief printing, the actual image is formed by printing the *raised*

surface that is left after cutting away the material of the matrix. Today, any material whose top or relief surface can be inked provides a matrix for printing. In modern relief prints, every conceivable surface able to be printed probably has been by someone. Traditional fine-cutting techniques are still practised as well; base cutting blocks are made of not only the more traditional woods such pear and box but also birch, cherry, walnut, gumwood, and so on, each yielding subtle individual textures. Rougher woods including chipboard, plywood, and density board—as well as other materials such as linoleum, rubber, plastic, and vinyl—have all offered their characteristics to the printmaker.

Many artists believe one of the main advantages of relief printing is that, apart from the making of the block, no major processing is required before printing begins. It is a direct method of printmaking: The paper and matrix are in direct contact as the print is made, and prints can be made with or without the use of a printing press.

In relief printing the surface of the matrix is inked, paper is placed on top, and a usually fairly gentle pressure is applied. This pressure can be applied manually with the hand, a wooden spoon, or a barren. It can also be applied by a press that exerts a downward pressure (such as an Albion Press), or, in a different type of press (such as a Van der Cooke, which is normally used for printing from lead type), by rollers, or on a flat bed offset proofing press. (See page 26 for the different types of relief printing processes.)

THE INTAGLIO PRINT

The idea of emphasising an image by rubbing pigment into lines is a very old one that dates back to cave paintings. However, it was not until the midfifteenth century that anyone thought of transferring that ink onto a piece of paper under pressure—and the printing process known as intaglio was born.

Intaglio is often colloquially referred to as etching. The word *intaglio* (pronounced with either a soft or a hard *g*) comes from an Italian word meaning "engrave." Intaglio prints are defined by their process—the technique of printing from a metal plate 1 to 2mm thick.

This is an old autographic process probably invented in the 1430s, although the earliest dated engraving was not made until 1446. There are many processes grouped under this category; they have in common the

incision of lines or images into a (usually) metal plate. The printing areas in intaglio methods are depressed below the surface of the plate. Incisions are made into the plate in various ways; it is the different techniques that distinguish the various processes of the intaglio family, the most common of which are engraving and etching. *Intaglio* is a generic term and includes engraving, drypoint, stipple-etching, mezzotint, hard-ground, soft-ground, lift-ground, etching and line etching, aquatint, sugar-lift, pochoir, photo processes, and others. (See page 33 for more details.)

In all intaglio processes, ink, which is less dense and viscous than that used in relief printing, is forced into lines or areas that are *below* the surface of the plate (the opposite of relief printing). In the intaglio studio, the plate is warmed gently and covered with this dense ink, which is applied with a "dabber" so that it penetrates all of the recesses in the plate. A muslin cloth is used to carefully wipe the ink off the top surface, with care taken to not drag ink out of any of the lines. This is a delicate and laborious process, and the printer must use a series of muslins in the wiping. The top surface of the plate is then thoroughly wiped clean with tarlatan. An intaglio press works on the same principle as an old-fashioned clothes mangle: When a dampened sheet of paper is laid on top of the plate, and pressure exerted as it is propelled through the rollers, the ink is forced out of the depressions in the plate and picked up by the soft paper. Again, it is a direct process where matrix and paper are in contact with one another.

Intaglio plates are made of metal, copper and zinc being the most common, but steel, brass, and bronze are also used. More recent materials include Cellulite, Plexiglas (Web), Perspex, and Japanese plastic plates, "Toray," and so on. Tools vary with each of the intaglio processes; in engraving (probably one of the oldest members of the intaglio family), the tool used is a "burin" (or "graver"). Engraving was traditionally made into copper; when large numbers of prints were required, the fine lines engraved in the copper would wear down. The invention of steel-facing for the copperplate in 1857 helped the engraver enormously; it meant that he could work on the copper (rather than the harder steel) but also have the original sharpness of his design preserved under a thin coating of steel.

The intaglio printer is important to the process because printing is such a skilled job. The difference between a well-printed and a badly printed impression from the same plate can be astonishing. Even the most skilled printer will take several minutes, if not longer, to ink up a plate. This makes intaglio printing one of the most expensive printing

processes—more so than relief, where the inking is simply done with a roller (although mixed media are far more expensive).

The pressure from the intaglio press produces the most obvious feature of intaglio prints—the plate mark. This can be recognised as an indentation in the paper formed when the edge of the plate is impressed during printing.

Paper also plays an important part in this process, as the difference between a good paper and an inappropriate one can have a huge effect on the appearance of the image. It is well known that many artists and printers amass collections of different papers to print onto.

THE LITHOGRAPH

Lithography is generally referred to as a planographic process. This is because the print is made from images laid down on a level surface (as opposed to incisions or raised surfaces).

The process, which is not quite two hundred years old, was invented in 1798 in Munich by the Prague playwright Alois Senefelder for printing his music more cheaply than engraving allowed. The process is based on the fact that grease and water do not mix. The artist's work consists of applying, in any greasy medium (such as oil-based chalk, ink, or liquid), a drawing or image onto a fine, granular surface—traditionally the best Bavarian limestone. Today, artists use either zinc or aluminium plate (or photo processes). Grease is essential to this process. An example of a most creative employment of grease was Picasso's use of his thumbprint to draw pictures of his children on a litho plate. The drawing is fixed on the stone or plate by rinsing with a weak acid solution.

The great surge in use of lithography by artists came after about 1820. One of the main attractions of the process is that the creation of an image on a plate or stone is almost as natural as drawing itself. Lithography is essentially a very versatile medium and in quality quite distinct from the two former processes. Senefelder, the inventor of the technique, foresaw almost all of its early possibilities—pen work, chalk drawing, splatter, and wash.

To make a print, the plate or stone is dampened evenly with water and a roller charged with greasy ink is passed over the plate. Because water and grease do not mix, the ink adheres only to the drawn greasy parts of the plate and is repelled by the parts covered by water. The

chief practical differences between working on a stone and working on a plate concern the chemicals and solutions employed and the fineness of the surface grain.

The traditional litho printing press is a flatbed "scraper" press. This is a direct method of printing in which the plate and paper, in direct contact (like a sandwich), are rolled along and squeezed together by the scraper bar. In hand-drawn (autographic) lithography, if the image is printed directly in this manner, the result is a mirror image—the reverse of the drawing on the plate. As commercial lithography developed through the nineteenth century, a rotary press was invented that offered "offset" press printing—the image is picked up from the stone or plate by an intermediary roller, which in turn transfers it onto the paper farther along the bed the right way round. This is called indirect printing.

One of the qualities most valued in lithography is its ability to record the finest nuances of shade, tone, and wash with the greatest fidelity, allowing a wide and subtle range of tone—from a very deep black to the tenderest of greys. A lithograph displays one of the finest and thinnest layers of colour that it is possible to print, and with its ability to offer direct autographic marks, it comes very close to the techniques of painting and drawing, easily distinguishable from the dramatic gouging effects of relief and intaglio processes.

The lithography workshops in Paris (such as that of Mourlot) played a major part in the development of artists' use of the technique. Matisse, Picasso, Braque, Chagall, and others vitalised this technique, stimulating a proliferation of lithographic artists in many other countries. In England, Graham Sutherland continued the revival of lithography employing subtle washes of transparent colour. In the United States, the Tamarind Workshop started in 1960 and Tatyana Grossman and her studio, Universal Limited Art Editions, established a centre for lithographic printmaking; Rauschenberg in particular came to love the process. His famous remark that anyone should be "drawing on rocks" (as he described litho stones) was indicative of an initial sentiment that disappeared as he began to use and understand the individuality of this process.

Much of the impetus for the new interest in lithography has come from individual workshops around the United States. Myriad creative techniques in photo-lithography, halftone, no halftone, colour separation, the use of frottage to transfer images, the use of magazine cutting soaked in a releasing solution, and so on were developed by the most innovative printers. Bob Blackburn, Ken Tyler, Margaret Lowengrund,

June Wayne, Gavo Antresian, and Clinton Adams are linked with some of the most fabulous prints being made today in the realm of lithography. In Britain, Stanley Jones has almost single-handedly kept autographic lithography alive. (See page 42 for more details.)

THE SCREENPRINT OR SERIGRAPH

Screenprinting is among the newest of the graphic techniques and has the shortest history as a medium for artists. It owes its origins to stencil making, although its actual birthdate is obscure. It has long been used as a stencil process, especially in Japan and China, both for making patterns and for printing on cloth (for which it is admirably suited, because it allows such a heavy deposition of ink).

Toward the end of the last century in France, a method utilising silk as a support for the stencil was developed. In screenprinting, this silk gauze is stretched tightly over a strong wooden frame, which is hinged to a table. A "squeegee" is used to push the ink from the top of the screen through the open areas of the gauze (or mesh) onto the paper below; the white areas of the image correspond to those parts where the gauze of the screen is covered (thus the ink blocked) by a stencil. The term *silkscreen* is occasionally used because silk was the fabric traditionally stretched onto the frame; nylon and polyester are more common screen meshes in use today.

Screenprinting has an alternative name; it has been widely known in the United States as serigraphy (derived from the Latin *seri*, "silk," and the Greek *graphos*, " to write"). Credit for the name *serigraphy* is given to Anthony Velonis, a painter and graphic designer, although the art historian Carl Zigrosser adopted the new name and used it widely in an attempt to distinguish artistic screenprinting from commercial printing.

One of the essential characteristics of screenprinting is the sharpness of the cut edge of the stencil and its resultant print (which, incidentally, allows it to be used commercially for typography and poster work). Around 1939, Anthony Velonis and others on the Federal Art Project in New York adapted the process more specifically for artists' use by dispensing altogether with the cut stencil and creating its equivalent by washout methods similar to lift-ground etching; thus the creative development of screenprinting by artists began. The American Guy Macoy claims to have been the first fine artist to use serigraphy,

beginning in 1932. The term *serigraphy* implies that, instead of using stencils, fine-art serigraphers paint or crayon their design direct onto the silk with an oil-based solution, fill in the remainder of the mesh with a water-based glue, and then wash out the drawing with a solvent that does not disturb the water-based glue filler—thus allowing a certain hand-drawn quality to the image. In England, Francis Carr claims he was the first artist to work serigraphically on pictures, beginning in 1949. It is true to say that the applications for screenprinting were at first largely commercial, and that it was not until the period between 1935 and 1950 that artists began to use and accept the process for their own expression—Harry Sternberg, Elizabeth Olds, and Ben Shahn are other key American figures in this development. However, the kind of collaborative screenprinting that developed during the 1960s—an artist working with a master printer—was not the hand-drawn type of work but a combination of hand-cut stencils and photo processes. Screenprinting proved to be an ideal medium for the pop art imagery of such artists as Andy Warhol, Jasper Johns, and Roy Lichtenstein, and from their time the medium achieved new popularity.

One of the greatest advantages of the screenprinting technique is the strength of its colour and the relative ease of multicolour work and overprinting. Thus when artists of the midtwentieth century turned to colour as the actual subject of their works, screenprinting served as natural medium. Screenprinting permits ink to be applied to the paper in any thickness; using oil-based inks, it has been possible to print white over black to cover the paper completely. Virtually any surface can be printed onto. This has allowed the medium to be very accessible, with much innovation taking place. Water-based inks are increasingly common and are at present required by law in many countries for health and safety reasons. (See page 45 for more details.)

THE MONOPRINT

A monoprint, monotype, unique print, or one-off is technically a print pulled in an edition of one; a single impression. Often, more than one impression is made from the matrix: the first one is strong in detail and the second and third appear like ghosts of the first. By this definition, it hardly fits into the multioriginal idea of printmaking; still, the work can only be made by utilising the idea of printmaking (in one of its processes)—

the picking up of an image from one surface and presenting it onto another. Therefore the monoprint certainly comes within our scope.

The first person to adopt the practice of monoprinting was probably the Italian artist Giovanni Castiglione, who developed the technique almost single-handedly in the early seventeenth century (around the 1640s). William Blake, another experimental printmaker, used this technique widely in combination with his etched relief prints. Edgar Degas explored the medium, and many others—Corot, Pissaro, Gauguin, and such diverse masters as Klee, Picasso, Matisse, and Roualt—have all found monoprinting suited to their different styles. Of course Whistler, in the late 1880s, made much use of it in his atmospheric prints, and in America J. S. Sargent and Frank Duveneck were both well known for using this method. It was an American, Charles A. Walker, who actually named this type of process *monotype*. (See page 50 for more details.)

Details of all of the processes encompassed by the umbrella techniques above are listed in the next chapter.

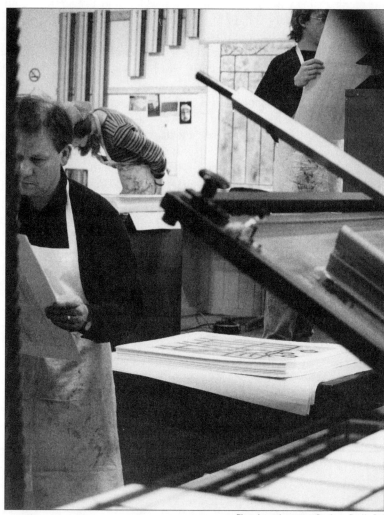

Photo by and courtesy Gresham Studio Ltd.

Gresham Studio Ltd., Cambridge, England. Kip Gresham, Ian Wilkinson, and S. Johnson printing an edition for Charles Sucsan.

Techniques In Printmaking

We are trying to describe a species so completely different from the actual means of description that clear definition and statement become almost impossible.

—S. W. Hayter

I t is useful and convenient to attempt to understand the terminology of contemporary printmaking. Cataloguing in salerooms, museums, and galleries inevitably leads to confusion, as interpretations and descriptions vary among authors. Here are some simple descriptions of the basic techniques of the major processes.

Some General Terms

Autographic

This term can be applied to all printmaking processes. The identifying element in autographic printmaking is that some part (and often all) of the work is done *by hand*.

Indirect print

This is a print made usually on a motor-driven machine with two fixed horizontal beds; the first holds the printing plate (or stone, or block),

and the second holds the printing paper. A pressure roller or a large, blanket-covered cylinder moves back and forth across the two beds, picking up the inked image from the plate and depositing it onto the printing paper. The result of the indirect printing method is that the printed image is the same round as that drawn on the printing plate due to the intervention of the roller. The indirect print is the opposite of a direct print, in which the printing paper is in direct contact with the printing plate and the image is reversed on printing.

Offset printing

Another name for indirect printing, involving the transfer of an image onto an intermediary roller then onto the paper.

Overprinting

This is a technique in which layers of (often transparent) colour (or varnish) are printed on top of one another. Sometimes, as in lithography, this allows the images below to show through. Oil-based screenprinting inks, however, generally cover up the lower colour when used to overprint as they are opaque (unless specifically made transparent).

Inks

Printing ink is (to all intents and purposes) historically an oil-based fluid, distinct from the water-based liquid used for writing. Printing ink was apparently invented or developed by Gutenberg and was as essential to his success as his invention of the printing press and movable type. Early inks were made by grinding pigment—notably lampblack—very finely and mixing it with oil. Hand grinding and mixing of printing ink still takes place in many studios today; less oil is used in relief printing and in intaglio in order to make the ink more viscous so that it will not run where it is not wanted on the plate. Lithographic ink has to contain grease to resist water. In screenprinting, the ink can almost be anything that will pass through the mesh and adhere to the paper.

There is a notable new trend in the production and use of contemporary inks toward awareness of the safety and health aspects of inks; the outcome has been that many printers are turning to water-based rather than oil-based inks. This trend is especially apparent in screen-

printing, whose harmful effects are well known. A new direction in intaglio printing—the use of water-based inks, pioneered by Canadian Keith Howard—illustrates that the new developments will change the "traditional" element of the process. Such changes are often resisted. However, they have become law in many countries. While this may offer new opportunities for artists and printers alike, it also means the collector will need to be aware of the subtle changes in the printed results.

Register methods

In each printing process in which more than one image or area of colour is used, there arises the problem of placing the second coloured image in correct relationship to the first—as well as to subsequent images. Various solutions to this problem exist in each process; they are generically termed methods of registration. Misregister is obviously the opposite. Occasionally, a series of registration marks is left on the print showing the method by which the paper was aligned on the same place on the bed of a press, and how the blocks, plates, or screens were registered. The buyer or collector may not be conscious of these marks—they are often hard to find except by scrutinising the small detail of a finished work:

- In screenprinting, if the paper used has four deckle edges, it becomes impossible to slide the wavy-edged paper exactly into card registration traps. Instead, small straight-edged cuts are taken out of the paper, usually at one corner and down the longest edge.

- In lithography, registration marks are occasionally seen as little crosses drawn on opposite sides on each plate; in proofing, the marks (one set for each colour) are aligned directly on top of one another. Once the position of the paper is correctly fixed, the marks are usually erased for the printing of the edition; in a few cases, the marks are left, and you can see the resulting buildup of colours on the cross marks. Needle registration is common also in lithography; the pin holes where the needle penetrated the paper as it was lowered onto the predestined mark on the plate are visible.

- In intaglio, it is the bed of the press that is usually marked with the position of the plate. After each inking, the plates are replaced

in exactly the same position. The position of the paper is also marked on the bed of the press so that each time a sheet is laid, the movement of paper (which takes place during the printing) is in the same direction.

- In relief printing, again the bed of the press is marked with the position of the blocks and of the paper. In each technique, the only criterion is that both the bed and the paper remain in constant relative positions. A "key" block is sometimes used in relief printing: The outline or most complicated block is printed first, and other areas are registered relative to the main block.

RELIEF TECHNIQUES

Relief printing works on the principle of cutting away parts of a matrix (traditionally a fine-grained wood) that are *not* required to print.

Relief Printing Presses, Letterpresses

Generally, a press is an indispensable tool for printmaking. However, artists can also print their own relief prints by hand. The technique is called burnishing, and it can often be recognised by the shiny outline contours produced by rubbing on the back of the paper. The differences between the final prints made by hand printing and press printing are usually greater in relief printing than in other processes—mostly because the hand cannot exert as much pressure as a machine. To overcome these differences, the use of a press is occasionally necessary.

Technically, there are three types of presses:

1. A platen, which has a downward action of weight.

2. A cylinder (flatbed offset), in which the printing (paper) surface is flat and the impression surface is cylindrical; the matrix is inked and transferred to blanket, and the impression from blanket to paper.

3. A rotary machine, in which both surfaces—the matrix and the impression—are cylindrical. The paper is gripped on the cylinder, which then runs over a printing plate.

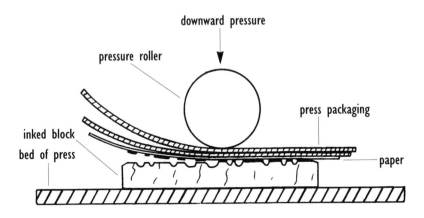

The principle of the relief printing process.

An Alphabetical Guide to Relief Printing Techniques

Bas relief or low relief prints Prints in which the image has become impressed into the paper, often by printing with either damp paper or heavy pressure—thus allowing a small "relief" to occur in the paper. Can be confused with relief etchings (see *Lino etching*, page 31).

Blocking This is the opposite of embossing. In blocking, a part of a work (usually a small area made by a block) is forced downward under pressure onto the paper, recessing it slightly. Blocking was commonly used with metal type on book spines in the past, but it is little used by artists today. Foil blocking is the practice where the block (usually metal) is heated and meets an intermediary plastic foil, which adheres to the printing surface relative to the hot parts of the block. Again, this is mostly used in glossy brochure or book production, not in fine prints. Tyler Graphics uses hot foil stamping in many prints they publish.

Block print A common term in relief printing with several meanings:

- The base matrix of any kind in relief printing is often termed a "block," with the widest reference—note, for instance, Bruce Mclean's use of potato and rubber stamps for printing.

- Any material assembled together into a group or block.

Carborundum print A print made from a surface built up from some form of glue, acrylic modeling paste, and so on. Carborundum grit is either mixed with the glue or sprinkled over the top while the glue is still setting; this gives a grainy, textured surface to the resulting print.

Cardboard relief print A print made in the relief manner from inked pieces of mat board that have either been glued to a base plate or remain individual and are often grouped together (like a jigsaw) to print. See *Jigsaw printing*, page 30.

Cellocut A relief print made from a surface built on a base made from liquid plastics (such as celluloid dissolved in acetone). It can also be printed with the intaglio process.

Chiaroscuro woodcut A technique for printing woodcuts in colour perfected in the early sixteenth century and used mainly by sixteenth- and seventeenth-century printmakers to produce a colour wash style. One or more wood blocks in two or more colours or tones were used. It was probably the first imitation of chiaroscuro drawings, in which the design is drawn in black on toned or coloured paper and the highlights are touched in with white pigment.

Chromotype A loosely applied nineteenth-century term for colour relief prints made from metal blocks.

Chromotypograph A colour relief etching.

Chromotypogravure A late-nineteenth-century term for a tinted relief halftone.

Collagraph An American term used to describe the printed result of a collage of materials glued onto a base. A collagraph is often printed as a combined relief and intaglio plate.

Colour relief print and colour woodcut It is unusual to ink a wood block in more than one colour and so a colour relief print often uses as many blocks as it has colours. The usual method is to make a key block

with a design in outline and print a number of sheets; these printed sheets are then pasted onto new blocks to act as a "key" to the cutting of other colour areas that, when printed, register with the final key block printing.

Colour in relief printing can be achieved in a number of ways:

1. Various wood blocks printed separately in register.

2. Stenciled colour applied to a master image block.

3. Relief compound print, in which separate parts of the matrix are inked separately and then reassembled for printing.

4. Key block printing (as above).

Criblé or stippled background A relief technique in which shaped punches are used to hammer indentations into a block or plate. It is an old technique that evolved around 1450. Where recesses were required over a large surface, the wood was not cut or notched but perforated with awls to produced a sort of "shotgun" effect. As side-grain wood could not be effectively worked with awls and a graver, plates of soft metal—probably alloys of tin, lead, and copper—were used. Of some interest among metal cuts is the dotted cut (criblé), in which the metal was cut with a goldsmith's punches (like toothed wheels) so that the background print had a sort of spotted look. In French, *manière criblé.*

Cut block print See *Jigsaw printing.*

Embossed print In this process, the image projects in great depth (or relief) above (or below) the surface of the paper; the paper used is generally of unusual thickness and strength to retain the impressed forms. In blind embossing, no ink is used and the resulting image simply appears in relief in the white of the paper. The method was first used systematically by Elisha Kirkall and Arthur Pond around the early 1700s.

Flexography In flexography, the image areas are raised (following the general relief printing principle) but the plate or block is made of rubber. These rubber plates are called stereos, and are usually mounted on a metal cylinder in the printing press.

Frottage Also called rubbing or brass rubbing, a frottage is a printable

impression made by rubbing or dabbing ink onto thin paper that is resting on a textured, raised, or carved surface. Rubbings have been made for many centuries—notably by the Chinese, who specialised in rubbing inscriptions on tombs, before the discovery of woodcut. Max Ernst is among the modern artists to have used this technique considerably.

Jigsaw printing This is a way of inserting colour (notably practiced by Edward Munch) in which the blocks are cut up like jigsaw puzzle pieces. Each part is separately inked, and then the pieces are reassembled for one passage through the printing press. See also *Cardboard relief print,* page 28.

Kiss impression In relief printing, a light print made by laying a thin sheet of paper over an inked block and rubbing lightly with the hand.

Letterpress A term for the commercial relief printing process. It often indicates the inclusion of the use of type and letters onto a print.

Linecut A method of relief printing in which the nonimage areas of the plate (metal or plastic) are removed, leaving only the line areas of the image to print.

Linocut Some artists today prefer using linoleum to wood because it is easier to cut. Lino is not suitable for the engraving of fine lines or for very small work, as it is too soft and crumbles easily. Various methods of linocut exist:

1. A technique in which the cut lines remain white and the background remains solid on the block.

2. A method in which the lines are left standing proud and the background is removed (see *Linecut,* above).

3. Reduction cutting or reduced method linocut. This method is easy to recognise. The artist uses a single block and makes cuts (which remain white in the finished work), usually printing the lightest colour first; further eliminations to the block are made and subsequent printings are exactly in register with the first; many colours are printed directly on top of the preceding colour; grad-

ually, a state in which very little of the block remains is achieved. The final printings are the darkest colours of the work. The characteristic of this print is that each colour has a lighter colour printed beneath it. It is sometimes called a reduction block print.

Lino etching This represents a block that has been eroded by the action of acid (usually caustic soda). A resist (often candle wax) is applied as the image; the whole block is coated with the acid to eat it away to the required depth. When both wax and acid are cleaned away, a print is taken. It is sometimes called a relief etching.

Metal cuts Metal was often given preference over wood not only for engravings but also for the cutting of lines. The techniques used in a metal cut are the same as those in a woodcut. With only a print to judge from, it is often difficult to recognise whether the block was metal or wood, but in a metal cut the edge and the lines sometimes look crooked or dented. The metal cut was in use particularly in the late fifteenth century.

Montage relief print See *Collograph*, page 28.

Photo-relief techniques Commercially, the photo-relief processes are called photogravure. They are prepared by exposing a film to a sensitised coating on a block that, when developed, is printed by the relief method.

Reduced method linocut See *Linocut*, opposite page.

Self-impression A print from any fairly robust material with a surface texture can be used to take a self-impression. Found materials are inked up and pressed into soft, bulky paper to give an exact impression of their nature.

Stamp print A print made by the stamping action of any block. (See also *Block print*, pages 27–28.) Commercial rubber stamps have been utilised for this process, as well as small wood blocks, vegetables, and literally anything that can be be printed with a stamping action.

Typography The use of lead or wooden type instead of a relief block. It is often called letterpress.

Woodcut The woodcut is the oldest known printing block. It acquired its greatest importance in the fifteenth and sixteenth centuries, after which its place was taken by the copperplate engraving and etching. Up until the last century, the woodcut had almost dropped out of favour until its rediscovery by Vallotton, Munch, and the Expressionists.

For a woodcut, the side grain of a plank of wood is used (the end grain is used for a wood engraving) and is usually about about one inch thick. The drawing is traced or pasted on the plank in reverse so that it will print the right way round in the print. The woodcutter follows the design with a special tool, making not a vertical cut but two separate incisions, one inclined away from the design and the other in the opposite direction so that a shaving of wood can be taken away. Large nonprinting areas are removed with a chisel or scoop. Wood is often sand-blasted through a rubberlike stencil, cut with a laser machine, or routed with a router.

In the past an artist made a design and left the cutting to a skilled craftsman—even Dürer did not cut all of his own woodcuts. However, today we would expect an original print to be cut by the artist.

States of woodcuts (see page 95) are rare because it is impossible to make corrections—what has been cut away cannot be replaced.

Woodcut in colour Colour woodcuts are thought to have originated in Germany at the beginning of the sixteenth century. Generally, a separate block is made for each colour. Often a key block that shows the black outline is cut first and used as a guide to the succeeding blocks, each of which bears a different colour.

Wood engraving The wood engraving was historically a modification of the woodcut (developed in the eighteenth century), although it is quite different in appearance. It is often held in low esteem by art historians and collectors mostly because it was developed purely for commercial reasons. Engravers use a block of well-seasoned, fine, end-grained wood such as apple, cherry, pear, beech, box, or even a harder wood such as oak; they cut along the grain using finely honed, sharp tools—knives, V- or U-shaped gouges. Large blocks are made by bolting together smaller blocks. A wood engraving can be confused with a metal one in that both the lines are incised; to print a wood engraving in the intaglio manner, however, would probably cause the block to crack.

Xylography From Greek *xylon*, "wood," it is another term for wood engraving. (See above.)

Intaglio Techniques

Intaglio Printing Presses

Most early intaglio presses were made entirely of wood, including the cylinders and the bed. In the early 1800s, metal began to replace wood. The tremendous, heavy, cast-iron frames and wheels and multiple reduction gears gave these presses—standing in rows in printing rooms—an almost giantlike look. Tremendous pressure is required to push the dampened paper into the finely inked crevices to make a print; this pressure is usually provided by a roller press with a movable bed. Felt blankets laid over the top of the printing paper cushion the paper, aiding its contact with the inked depressions. Studios such as Tyler Graphics have pioneered new techniques, such as using a platen press to print intaglios.

An Alphabetical Guide to Intaglio Techniques

À la poupée One of the earliest methods of colour printing using intaglio. This process, in which many colours are inserted onto a single plate with the aid of little dabbers, is called à la poupée (with a dolly), or sometimes dolly printing. The dabbers or stumps of rag used for applying the inks look a little like rag dolls. The coloured print is the result of only one printing operation.

Aquatint This process was invented by Frenchman Jean Baptiste Le Prince around 1768; in French it is known as *manière de lavis*. It is a method in which a uniform tone is produced on an etched plate by the intaglio process; the effects are similar to a wash. The surface of the plate is dusted with a porous ground such as fine rosin or asphalt powder, which, when heated, adheres to the plate. The parts of the plate intended to appear white are then covered by a protective varnish. The acid attacks the parts of the plate not covered by resin or varnish. This process of protection by varnish and biting is repeated until the desired range of tints is created. Only an aquatint can create even tones without gradation or blending; the characteristic aquatint grain is easy to recognise (in the finest cases under a microscope). Aquatinting is often used in conjunction with the etching process. An aquatint can also be made by applying an enamel

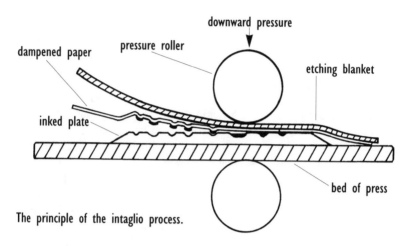

downward pressure

dampened paper

pressure roller

etching blanket

inked plate

bed of press

The principle of the intaglio process.

or stop-out spray to the plate using spray guns or air brushes. See also *Flower of sulfur aquatint.*

Blind intaglio print The result of printing an uninked, deeply etched plate. Also called a blind embossing or blind intaglio print. See also *Embossin*, and *Die stamping.*

Chemitype An unusual process used in the midnineteenth century involving the transforming of an intaglio plate into a relief block. The etched lines on a zinc plate were filled with molten metal, which was able to resist the action of the acid as the plate was bitten down—reversing the process.

Colour intaglio prints Coloured intaglio prints can be made by a variety of methods:

1. Individual plates can be used for each different coloured ink and printed after each other in registration. (This is sometimes called the French method.)

2. In the à la poupée method, many colours are inserted into different parts of a single plate (see above).

3. Different viscosities (or thicknesses) of ink can be placed on different levels of the bitten plate.

4. Many plates cut to fit together can be inked individually, assembled, and printed at one time.

Copperplate and steel engraving The very oldest intaglio plates are known as copperplate engravings—a name that even today commands respect. The engraving technique was probably invented by goldsmiths who used it to decorate goblets, sword and dagger blades, and the like by pushing pigment into incised lines to make them more noticeable. Early intaglio prints are known as niello prints; in these, a black, enamel-like substance was usually forced into the engraved lines. The process requires skill and care, and it is not as popular with artists today as it does not easily permit free, spontaneous work.

Engraving lines into copper—clearly distinguishable from lines made by the etching process—is the traditional manner; however, another metal, steel (which is considerably harder than copper and can last through much larger editions), became very popular until steel-facing was invented. As copperplates can now be steel-faced by electro-deposition, the advantages offered by steel plates are no longer of primary concern.

In French *gravure en taille douce*, the term *engraving* refers to the process and also its result. (See also *Engraving*, page 37.)

Deep etching A very deeply bitten plate—one left for hours in the acid—will produce prints with a deep, relieflike surface. A particularly bulky paper is required for printing.

Die stamping An intaglio method in which an inked (or uninked) copper or steel plate (the die) is printed under very heavy pressure. Sometimes the opposite of the die is used at the same time and the two blocks (negative and positive) squeeze the paper together, resulting in a heavily embossed image.

Drypoint A technique in which marks are made directly onto the metal plate with a sharp, pointed, steel needle. As the needle scratches the plate, a burr of scraped metal forms around the edges of the line. The burr is not taken away (as in line engraving) and therefore it retains the ink; when printed, a very delicate, velvety shading occurs (sometimes called a "rich smudge") around the edges of the lines. This is characteristic of the drypoint technique but it wears off quickly in the printing, often only lasting for twenty to thirty impressions. Drypoints are often still made in the traditional manner onto copperplate. This process can easily be confused with etching.

Christopher Bacon at work in the copperplate intaglio workshop when it was based at Cherryburn Museum, Northumberland, England.

Dust-grain gravure An old technique of photogravure in which aquatint dust is laid on the plate before the photo-sensitive gelatin. Special effects occur when the plate is bitten in acid.

Embossing Any process used to create a raised (or depressed), usually uninked surface. The techniques of etching, stamping, carving, or even casting found objects, male and female dies, and so on can all be

used. A blind embossing is a print made without ink. (See also *Blind intaglio print.*)

Engraving A technique of incising lines in which the surface of the plate is cut into with a very sharp engraving tool called a graver or burin. The plate is placed on a leather, sand-filled bag during cutting to allow the cutter easier movement. The action of the graver on the plate produces a groove in the metal plate; at the edges of this groove, a characteristic raised shaving of metal occurs called a burr. In an engraving, the burr is usually removed with a triple-edged scraper and burnished. This is a "serious" technique with little room for free movement—in the past, professional engravers used this process to sign their names into the plate.

Etching The first dated etching was made in 1513. In this process—one of the oldest of the indirect intaglio techniques (Dürer experimented with iron plates)—the depths or different levels of a metal plate are created by the chemical action of an acid, instead of by the mechanical action of an engraving tool. The artist paints his design on a clean plate with an acid-resistant ground (usually a mixture of resins and waxes). If the plate is totally covered, it can be worked into to reveal some of the metal beneath in the form of lines made, for instance, with a wooden-handled round needle. An oval needle known as an echoppé is sometimes used as well; on turning while drawing, the characteristic width of the line is altered. Any scraping tool, in fact, can be used—even a screwdriver. The unprotected metal is "eaten" or "bitten" when the plate is left in an acid bath. The depth of the bite depends not on the pressure exerted by the hand, but rather on the duration of the immersion in the acid. This is one of the processes that allows the artist the freedom of drawing marks by hand. (See also *Soft-ground etching*, page 40.)

Flower of sulfur aquatint This is a print produced by dusting powdered sulfur onto the surface of a plate that has been spread with a layer of oil. The particles of sulfur corrode the plate in a uniform tone, which can then be burnished to give gradations.

Gauffrage, gauffering From the French *gaufrure*, a gauffer or goffer is an impression of sunken and raised motifs from an engraved plate or

wood block made onto paper. The relief on the plate appears as sunken imprints, while sunken motifs on the plate create relief marks. An example of this would be square of colour being printed with one block, while a pattern on it was impressed with gauffering as a blind embossing.

Gravure printing See "Photo-Related Techniques in Printmaking," pages 52–57.

Hard-ground etching See *Soft-ground etching*.

Heliogravure This is an old French process based on the aquatint. Today, work is usually reproduced photomechanically and printed on a gravure press. (See also *Photogravure* and "Photo-Related Techniques in Printmaking," pages 52–57.)

Line engraving This is an intaglio technique in which the image is made by scored lines of varying width on a metal plate. The burr thrown up by the engraving tool is removed with a scraper. (See also *Engraving*.)

Maculature An intaglio technique for cleaning ink from a plate by pulling two proofs (see pages 113 and 114) without inking between the printings.

Metal print A process attributed to the artist Rolf Nesch, in which metal objects such as washers, wire, meshes, or other *objets trouvés* are adhered to a plate and run through the press, producing unique images in great depth. (Rolf Nesch was also the first artist attributed with making holes in his plates for aesthetic purposes.) Also called metal graphics. (See also *Metal relief print*.)

Metal relief print

1. A relief print made from a metal collage or etched metal plates.
2. During the first hundred years of European relief printing, craftsmen occasionally used metal instead of wood to make

relief prints; the technique used in this process is most often referred to now as "metal cuts in the dotted manner," hence the French term *manière criblé*. (See also *Relief etching*.)

Mezzotint An intaglio image-making technique in which the plate is worked from dark tones to light with a special tool. A negative process, the mezzotint technique consists of first roughening the surface of the plate with a very fine toothed tool called a mezzotint "rocker" or "roulette" (available in varying grades) so that if the plate were to be printed directly the resulting print would be totally black. The artist then does his drawing by making white lines and marks with a special scraper that erases the pitted holes and smooths the plate—thus giving lighter areas to the print. One of the special qualities of a mezzotint is the very sumptuous, rich, dense black created by action of the rocker. Also called *manière noire* or the "black method."

Mixed method intaglio prints

1. An artist with many different intaglio techniques at his disposal often incorporates several intaglio methods in one plate—etching, engraving, soft or hard ground, burnishing, drypoint, gouging holes in plates, deep biting, and so on.

2. *Mixed method* can also refer to mixed printing processes—for instance, relief, intaglio, and screenprinting—in one work.

3. In colour printing, *mixed method* can also refer to one plate whose depths are printed intaglio, and whose top is rolled (as in relief) for surface tones.

Niello See *Copperplate and steel engraving*.

Open bite A plate that is freely bitten by acid—one without any ground, varnish, or other substance that would resist the acid. With this method, it is possible to achieve completely free or "chance" expression.

Paste print An intaglio print made on paper that is covered with a doughlike substance. It was first used in late fifteenth century.

Photo-etching techniques See "Photo-Related Techniques in Print-making," pages 52–57.

Photogravure The commercial application of the intaglio process. See "Photo-Related Techniques in Printmaking," pages 52–57.

Relief etching This technique was probably developed initially by artist William Blake, who wanted a method of printing his own visionary books. He drew his designs in acid resist liquid onto copperplate then etched away the unwanted parts of the plate leaving the drawn lines standing up. He printed the plate as a relief block. (See also *Metal relief print.*)

Retroussage An evocative term for a skill in which a feather or cloth is used to tease a little ink from the lines after a plate has been wiped for printing—imparting a richer and possibly more romantic quality to the image.

Sandblasted plate A sandblasting process can be used to prepare the surface of a metal plate, giving the resulting print a texture that resembles an aquatint or mezzotint. It is also used to make wood cuts.

Sandpaper aquatint An aquatint produced by running the plate through the press with a piece of sandpaper face down on it.

Soft-ground etching In this process, the plate is coated with a soft, sticky, liquid resist. A thin sheet of paper placed over the top is then drawn onto by the artist; the pressure exerted causes the soft ground to adhere to the paper, thus exposing the metal. After the plate is etched, the impression remains fixed in the metal. The plate is bitten in the acid and the ground cleaned off before printing. The result is a facsimile of a chalk or pencil drawing. The earliest print of this type was probably made by Castiglione, and is dated around the 1640s. Prints made from a soft ground are gentler and more delicate than ordinary etchings. With soft ground, almost any kind of texture can be reproduced, and any material with a rough enough surface can be pressed into the soft ground to leave an impression of itself. Under a microscope, it may be possible to distinguish soft-ground etchings from true aquatints by the absence of the rings or pools of ink that form around the resin particles.

The opposite of soft-ground etching is hard-ground etching, in which a less sticky liquid is used to coat the plate and then drawn into or scraped away with a pointed tool.

Spit biting An aquatint technique for achieving graduated tonal effects by applying acid with a brush containing saliva or water.

Steel engraving A nineteenth-century technique for engraving on steel. Steel is a harder metal than copper and thus can be used to make larger editions than those possible with copper.

Stipple-etching Stipple and other dotting processes create the effect of tone in an image. The design is built up by thousands of minute dots worked through a ground on a plate, with either a needle or a roulette. The plate is bitten in the usual way. A stipple-engraving or "flick-engraving" is created on an ungrounded plate with a special tool called a stippling burin. These techniques were perfected and at their heyday in the late eighteenth century.

Steel-facing A process for adding pure iron to a metal intaglio plate by electro-deposition.

Sugar-lift aquatint In this process, the plate is resin-dusted all over—as in a normal aquatint—but then the artist makes a positive drawing with a special medium that contains sugar, ensuring that it will never completely dry. A varnish (possibly asphalt) is then laid over the plate, which is immersed in water. The sugary drawing under the varnish is attacked along its edges, causing the varnish to lift; this exposes the plate for aquatinting in the usual way. This process enables the artist to capture a spontaneous gesture in the intaglio medium. See also *Aquatint.* Another variety of sugar-lift called "etching à la plume" produces the effect of a pen line.

Sulfur print See *Flower of sulfur aquatint.*

Viscosity printing An intaglio method based on the principle that inks of different viscosities applied to different levels on a multilevel plate do not mix when run through a press. Plates are inked by wiping and by a mixture of soft- and hard-rolling techniques.

LITHOGRAPHY TECHNIQUES

Printing Presses

Senefelder's first press was a wooden etching press that he adapted for use with a stone. His "pole" press incorporated the scraper principle and applied pressure through a series of foot-operated levers. However, a better press—the forerunner of most of the presses built for litho stones—was invented around the early sixties by Herman Joseph Mutterer in Munich. Senefelder did actually invent an ingenious portable press, which by all accounts was not very popular. Different presses—such as the star wheel press, geared metal presses, and, early in this century, a metal press with a unique top-lever pressure—were developed. Mechanized presses, the first operated by steam pressure, eventually took over from the hand-operated presses. Today, the most popular press is probably the offset, although many old presses still exist—both direct and indirect, hand-operated and mechanized.

An Alphabetical Guide to Lithography Techniques

Algraphy Lithography on aluminium plates, as opposed to zinc or limestone.

Anastatic printing This is, in essence, a method of transfer lithography in which a page is soaked to loosen the grease of the ink; the image is transferred onto a zinc plate, which is then treated as a lithograph.

Chromolithograph A term for a colour lithography technique that was almost exclusively used for reproducing paintings and watercolours. It was in popular use from the second half of the nineteenth century.

Colour lithograph Since a stone, like a wood block, can usually only be inked easily with one colour, colour lithography usually employs as many stones or plates as there are colours—although extra colours are often created by overprinting. Registration was initially done by sticking pins through the paper at predestined, and often printed, marks,

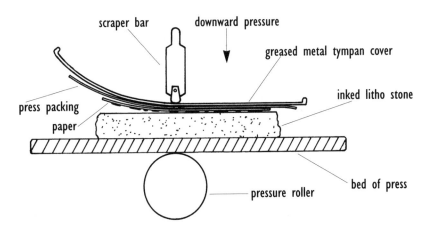

The principle of the lithography process.

then inserting these pins into minute drilled holes or drawn crosses at the same point on each stone or plate. Today, with offset printing and registration grippers, these telltale marks are not needed.

Continuous-tone lithography See "Photo-Related Techniques in Print-making," pages 52–57.

Crayon lithography This technique—utilising a greasy crayon—produces a print that could easily be taken for a drawing itself.

Diazo lithography See "Photo-Related Techniques in Printmaking," pages 52–57.

Gradated roll A specialised technique in which a plate or stone is inked with strips of different colour, or different shades of the same colour, which are blended at the edges and printed simultaneously. It is sometimes referred to as a "blend" or a "rainbow roll." (See also *Colour lithograph,* opposite page.)

Litho aquatint A recently developed technique for creating fine tonalities and wash effects on metal plates.

Offset lithography This refers to the printing technique in which an inked image on the litho plate is printed by first offsetting it onto an intermediary rubber blanket, then transferring it onto the printing paper; thus the image prints the same way round that it was drawn. (See also *Indirect print* under "Some General Terms.")

Oleograph A nineteenth-century process whereby an ordinary colour lithograph was varnished and impressed with a canvas grain before publication in order to make it look like an oil painting.

Photo-lithography Photo-lithography is a generic term for any technique for producing an image on a lithographic plate by photographic means. See also "Photo-Related Techniques in Printmaking," pages 52–57.

Planography A broad term for printing from a flat surface; it usually refers to the lithographic processes, but can also refer to screenprinting.

Plate lithography Because of the cost and scarcity of Bavarian limestone for image making, many lithographs are today made onto a metal plate of either zinc or aluminium. These materials are not naturally porous, but the surface is roughened to become receptive to both grease and water.

Stone lithography Bavarian limestone is the best traditional stone for lithography; it is also heavy, fragile, and expensive.

Tone lithography A series of new techniques, developed in the last decade (in England by Kip Gresham and Stanley Jones), in which artists draw onto a clear film that is then put onto the plate by photo methods—but without requiring a halftone screen. This is often referred to as "Mylar lithography" in the United States. See "Photo-Related Techniques in Printmaking," pages 52–57.

Transfer lithograph A lithograph whose image was created elsewhere than on the final printing surface, and was then transferred to the plate by one of various processes. Images from magazines have been transferred in this way directly onto a litho plate without the use of photography.

Tusche-wash lithograph A technique for drawing in which the litho

liquid medium (tusche) is diluted with anything from distilled water to benzene. This gives a fascinating and immediately recognisable "litho wash" quality to a print.

Xerox A xerox powder chalk technique was invented by Nik Semenoff at the University of Saskatchewan, and is used extensively at Tyler Graphics on such prints by Joan Mitchell, David Hockney, and Terance La Nove.

Zincography A nineteenth-century term for lithography on zinc plates.

SCREENPRINTING TECHNIQUES

Printing Base

In screenprinting, a mesh is stretched under pressure over a strong wooden or metal frame. Initially, this strong frame was hinged to a table—often called a printing bed—which permitted the printing of different colours in register. Technical developments came early in this century: By 1916 the photo-stencil had come into use, and by the 1920s the first automatic screenprinting machine had been invented. Today, automatic screenprinting beds are used in most workshops. They consist of a heavy-duty metal table whose top surface contains a vacuum system, which holds the paper firmly in place as the hinged screen is lowered for printing.

An Alphabetical Guide to Screenprinting Techniques

Blend A specialised technique in which a screen is inked with several different colours at once; they blend into one another as the squeegee traverses the screen. It is sometimes called a "rainbow" print.

Blockout print A liquid (the basis of any image) is used to fill the openings in the screen mesh, which consequently appear as the non-printing areas. Many ordinary substances, such as water-based glues, shellac, and so on, can be applied directly to the mesh to form these

very simple stencils. A reverse blockout stencil occurs when the entire surface of the screen (after the first drawing has been made) is filled with the reverse base of the initial drawing fluid; the initial drawing is then washed out with its own solvent. The open (printing) areas then appear as those of the original drawing onto the screen. Examples of blockouts include glue, shellac, lacquer blockout, litho crayon, tusche, rubber cement, and latex.

Flocked print Initially, a "curious and rare" class of fifteenth-century woodcuts in which the block was inked with glue and printed onto paper on which a fluff of minced wool was then dusted. A similar process was later developed for wallpaper. In the context of fine prints, the term now describes a similar but more refined process in which an image screened in an adhesive varnish is sprinkled with wool or rayon flakes.

Hand-cut lacquer film stencils Hand-cut lacquer film comes in a variety of bases and colours but, when adhered to the screen, produces a strong stencil that gives a sharp, hard edge to the image. Hand-cut film is also manufactured as a water-soluble film.

Mitography A synonym for serigraphy proposed by Albert Kosloff but never widely adopted.

Paper stencil In this direct and easy method of stencil making in screenprinting, tracing paper, newsprint, or layout paper can be used as a block for the ink attached to the underside of the screen.

Photo-screenprint A range of techniques for producing an image by transferring photographic images to a stencil for screenprinting. See also "Photo-Related Techniques in Printmaking," pages 52–57.

Pochoir A printmaking technique using a stencil made of plastic, copper, brass, or oiled paper. It was originally used for applying small areas of colour to a print.

Screen-process printmaking Often simply the commercial name for screenprinting or serigraphy.

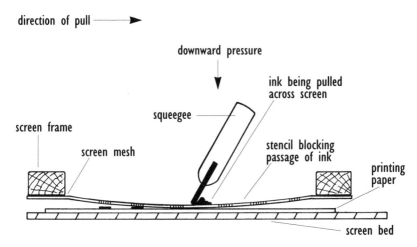

The principle of the screenprinting process.

Silkscreen The term originally used for screenprinting, mainly because silk was used as the mesh for the screen frame. Silk meshes have now been completely replaced by synthetic meshes, therefore the term is misleading. *Silkscreen* can refer to the print as well as the process.

MISCELLANEOUS TECHNIQUES

Methods of printing that do not fit easily into any of the above processes:

Assembled plate A plate composed of fragments of manufactured objects, printing elements, or found objects. For printing, they are either attached to a single backing board, or assembled unattached to a base on the bed of the press. Prints from assembled plates can be made by embossing, intaglio, and relief printing—and even by monoprint techniques.

Cast-plate intaglio Intaglio plates can be made in cast, nonferrous metal (bronze, copper, aluminium, stainless steel, or zinc) or in plastic

and then printed by the same techniques employed for engraving or etched plates.

Chine appliqué A method of adhering one sheet of material (often thin paper) to another with glue under pressure.

Chine collé A technique for pressing a thin sheet of sized oriental paper to a heavier backing sheet and, at the same time, printing it. This can be accomplished by both intaglio and lithographic printing methods.

Composite print A print made from a number of individual blocks, plates, stones, or stencils that combines different techniques in the same work. Also called mixed media.

Dye transfer A few modern printmakers, notably Richard Hamilton, have used this method. A gelatin matrix is made photochemically for each colour; the matrix is then saturated with dye and printed by pressing against an especially absorbent paper. The tendency of the dye to spread gives the finished print a soft, blurred character. Occasionally, artists use a Xerox print as the matrix; it is saturated with a chemical to release the image, which is then pressed onto paper.

Embossed lead print A technique—used especially by Robert Morris and Jasper Johns—for creating editions in lead by using both a negative and a positive mould in a hydraulic press. (See also *Die stamping* under "Intaglio Techniques.")

Incunabulum This term covers printed books before 1501 and also is a generic term describing documents relating to the history of anything. In printmaking in particular, it is the generic term for any relief or intaglio print found in the early books of woodcuts, which often had illustrations and text printed on the same page.

Inlaid plate Any plate embedded into a larger plate.

Mixed media, multimedia Terms used to describe prints that utilise a combination of techniques in one work. See *Composite print*, above.

Monochrome print A print that is printed in a single ink only—traditionally black. Many works printed in monochrome have been tinted or coloured by hand.

Nature print One of the most ingenious of Victorian inventions. A vegetable object (such as a plant or leaf) was impressed under considerable pressure into a soft lead plate. This was then stereotyped or electroplated and the plate printed in intaglio to produce an astoundingly accurate image of the original. The process was patented by Henry Bradbury in England in 1853.

Plaster print

1. An intaglio print made in plaster (of paris) instead of paper.

2. A paper print taken from a plaster block.

Press moulding Press moulding is done by heating a sheet of plastic until it is pliable, then clamping it between negative and positive moulds.

Vacuum-forming Plastic sheeting can be vacuum-formed over any object within its stretching limitations. (Claes Oldenburg's *Teabag* is an example of a vacuum-formed object.)

COLOURING BY HAND

Hand colouring is a recognised technique; indeed, some of the oldest prints were coloured by hand. Today the practice continues in a multitude of forms; hand colouring of either individual prints or the whole of an edition can be achieved by any means the artist wishes to use— watercolour, crayon, coloured pencil, and so on. (A technical point to consider when looking at a print is whether the colouring has been fixed.) The colouring of an edition (or a few proofs) is called "enhancing"— hence "enhanced proofs" (see page 97). However, the hand-colouring process is not a printmaking process and may raise questions of connoisseurship. As Zigrosser explains it, when a print is published and printed, the colour is printed, and there can be little doubt as to the artist's intention and choice. If, however, the print is represented as

"coloured by the artist," how is one to know except by explicit proof? As an example, the difference between a print coloured by William Blake and one coloured by his wife should be considerable in terms of merit—yet the only verification generally offered is attribution.

However, my view is that if the print is signed by the artist, the signature is verification that the result is the artist's intention and choice. It should be noted that hand colouring may vary considerably, within the edition.

MONOPRINTING TECHNIQUES

A monoprint (also called a one-off, monotype, or unique print) can be made in a variety of ways :

1. A painting can be made in any ink on top of a sheet of glass, metal, or plastic, worked into with a needle or any tool, then wiped away, or washed, blotted, scrubbed, and so on. When a sheet of paper is impressed on top by whatever method (through an etching press or a litho press or simply by hand pressing or rubbing from on top), the impression from the base will be transferred directly onto the paper.

2. The transfer print. Degas and Klee used this method extensively. It is recognisable by the original drawing on the back of the print.

3. Many contemporary monoprints use the screenprinting process: The artist draws on top of the mesh with ink, pulls the squeegee over the mesh, and the work is transferred onto the paper below.

Monoprints can also be made on a flatbed offset press: the matrix is inked freely—using crayons, brushes, or fingers—then transferred to blanket, then to paper—once or many times.

A monoprint is a unique work. A second print can be taken from the plate or screen, but it often is a pale (or ghost) reflection of the original and close to the nature of a maculature (see page 94).

Some monoprinting (one-only) and related techniques follow:

Decalcomania A simple technique, associated with work of Max Ernst, in which ink or paint is applied to one side of the paper, which is then folded and pressed so that a direct print is obtained on its opposite side. It is often recognisable by the fold in the paper.

Monographic print A print in which several different and complex transfer images have been made. It can be produced in an edition, but it is usually only produced as a one-off. Hayter describes one aspect of this in his book *About Prints*. An instance is when an ordinary object is rolled up in colour and an impression offset from it onto a rubber or gelatin roller; the impression is then deposited onto a piece of paper. An image is made up by repeating this single offsetting procedure with different objects and textures. Much improvisation occurred in the early days of printing the "found image."

Transfer print, transfer drawing This is another name for a drawing made by the monoprint method in which a sheet of paper is placed over the top of a (dryly) inked base and a pencil (or a finger, the end of a brush, or another hard instrument) is pressed lightly from the top; the ink transfers from the base block only in the parts that are pressed into the base. It was used by Klee and Gauguin to achieve special effects, and also used effectively by Hedda Sterne and Carol Summers.

Self-impression An impression taken from any material with a surface texture. As an example of this, many bodies have been printed!

THE PHOTOGRAPH

Photographs are now collected by the print-collecting departments of many European and American museums, although they are not prints in the conventional sense. During the early years of photography in the midnineteenth century, many artists considered photography to be less an exciting additional medium than a threat to their livelihood. Delacroix, Manet, and many other artists made use of photography but when it became widely adopted by the commercial

printing industry to produce cheaper and quicker illustrations, many artists dissociated themselves from it.

One of the reasons it took so long for photography to be accepted as art form may be that it was thought to be unduly mechanical, its materials have been also fugitive and the development colour was in its infancy. It has now achieved respectability, however, and artists who make photographs (as differentiated from professional photographers) have entered the art market. Photographers have long had their own exhibitions and the special qualities of photographs are clearly appreciated, despite the fact that today almost everyone takes photographs. As photographs are also offered for sale in signed, limited editions by reputable galleries, the negative can be seen as equivalent to the printing matrix, with many identical copies being made. It is difficult to argue that they are not prints. I personally think, however, that they are a distinct enough group not to require inclusion in the category of artists' original prints. Borderline cases—such as photographs that are stuck onto artists' prints, or photographs on top of which artists have added work by hand or screenprinting—blur precise definitions. To some extent it must remain a personal choice whether these and other borderline cases are acceptable or not as original prints, since the loose usage of the word *print* creates many ambiguities.

PHOTO-RELATED TECHNIQUES IN PRINTMAKING

Photography has a natural affinity with print and printmaking processes. It was not long after William Henry Fox Talbot patented his method for making a photographic etching on a steel plate (1852) that photo-screenprinting was developed. From this basic process evolved, over a century or more, the photographic screenprint. Great contemporary exponents of the photo-stencil and photo-image include Paolozzi, Kitaj, Wesselman, Rosenquist, Rauschenberg, Warhol, Rivers, and others.

Many of the photomechanical printing processes are based on Poitevin's discovery of the sensitivity to light of bichromated gelatin. This substance hardens when exposed to light and remains soft where shielded from light. The other development crucial to many of these processes was the halftone screen. Continuous tone in a black-and-white photograph is due to the variable darkening of silver salts in the

emulsion. To translate this into relief, intaglio, litho, or screenprinting—all of which are binary systems, that is, made up of ink and nonink areas—an optical illusion is utilised. The halftone system is used for most commercially printed illustrations and reproductions. The photographic negative is put into contact with a screen of fine crisscross lines; light tones come out as fine dots and dark tones seem to be continuous, as in a photograph. The dotted image is used to make photo-blocks, photo-plates, and photo-screens.

Photographic images could be produced quickly and cheaply and, of course, in photography's early days these very commercial advantages aroused suspicion; many artists questioned a medium dependent on chemistry and mechanics rather than autographic control. Post-World War II technical developments using photography in commercial printing coincided with a new movement in art toward deriving its images from the cinema, advertising, and photojournalism. This led naturally to screenprinting, the medium that offered the greatest flexibility for the incorporation of these photo-based images—although they also appeared in other types of prints.

An Alphabetical Guide to Photo-Related Techniques in Printmaking

Blueprint, brown sepia print These are special techniques whose recent development is attributed to Paul Clinton at Graphicstudio (University of South Florida, Tampa). The printing paper itself is coated with a sensitised chemical solution, exposed to a Kodalith image, developed in a specially mixed solution, and then fixed. The processes—blueprint and brown sepia—are performed separately.

Carbon print Perfected in 1864 by Sir Joseph Swan, the carbon print consists of a tissue of carbon impregnated with gelatin treated with potassium bichromate to make it light-sensitive. Superficially, the carbon print looks like a conventional photographic print; it is not susceptible to fading, however, because the carbon pigment is stable.

Cliché verre A French term for a glass print. This is an engraving technique developed about 1850 in which a piece of glass is given a black

coating and then scratched with a needle, as in etching. The actual printing process is like developing a photograph, where you start with a negative.

Collograph Easy to confuse with *collagraph* (see page 28). Henry Moore adapted the collotype process (see below) from its commercial use in colour reproduction as a means for original expression. He drew on separate transparent plastic sheets for each colour; these were then transferred to collotype plates by light.

Collotype Often confused with collagraph (see page 28). Patented in 1855, this is a high-quality reproduction process in which a gelatin-coated glass plate holds the image. It is based on the properties of gelatin, which is insoluble in cold water but dissolves in warm water; sensitised gelatin exposed to light will harden and become nonabsorbent. The name comes from the Greek *kolla*, for "glue." As each new modification of this process was spawned, however, a new commercial name appeared—in addition to collotype, this type of process is also referred to as albertype, phototint, heliotype, hydrotype, and even autogravure and photogelatin printing.

Colour process printing, colour separation Sometimes called full-colour or four-colour printing, this process is based on Newton's theory that all colour is composed of three primary elements—red, yellow, and blue. A photographic negative separation of each colour from a full-colour tonal original is made using filters, which are then transferred into a series of elliptical dot screens (each colour separation aligns the dots at a different angle). The three plates are then successively printed to build up the coloured image, and a fourth printing—black—is added to strengthen the shadows. Since the late 1940s, most colour separation work has been taken over by various types of electronic scanners.

Continuous-tone image A photographic image—either positive or negative—that contains a full gradation of tones.

Continuous-tone lithography A form of transfer lithography in which a film drawn by the artist is exposed onto a specially made, light-sensitive aluminium printing plate.

Cyanotype, gum-iron process In cyanotype processes, the paper is sensitised with ferric ammonium citrate and potassium ferricyanide. Exposure to light reduces a portion of the ferric salts to ferrous states and a portion of the ferri- to ferrocyanides, resulting in a pale blue-white image. A cyanotype is a blue image on a white background, the reverse of a blueprint—although the two are often thought to be the same. See also *Blueprint*, above.

Diazo lithography Modern lithographers often use a technique known as diazo lithography in place of transfer lithography. Instead of drawing onto a transfer paper, the artist draws onto a sheet of transparent film. This is then exposed photographically onto a photo-sensitised plate. The term *diazo* merely refers to the name of some of the chemical compounds. The results of this technique can imitate a continuous-tone original without resorting to a halftone dot.

Dye transfer A method of producing a photographic print that offers greater colour density and more permanence than does the normal emulsion process. The printing surfaces are formed by gelatin matrices, one for each colour separation. The matrices are emersed in dyes of the appropriate colours and printed in sequence in exact register onto specially prepared absorbent paper.

Gravure printing *Gravure* is a shortened form of *photogravure* which describes all the intaglio processes made by using photography. See *Photogravure*, below.

Gum printing Gum dichromate is probably the technique most responsible for the revival of this historic process. Gum prints can be made in any colour. Although the cost is low, the main drawback for many artists is that a gum print cannot register fine detail.

Halftone The process of photographically reproducing a tonal image by the use of a crossed-line screen interposed between the object to be photographed and the film. The range of tones on the original is interpreted on the negative by a mass of dots equally spaced but varying in size, giving the illusion of continuous tone.

Heliogravure A photomechanical intaglio printing process. (See *Photogravure.*)

Heliotype See *Collotype*, page 54.

Kallitype This process was conceived in England. The name dates back to 1889 and the work of W. J. Nichol in Birmingham. The chemistry of kallitype is similar to that of platinum printing, the main difference being that the kallitype image consists of silver nitrate and ferric salts—exposure to light reduces some of the ferric salt to a ferrous state. It is commonly known as the vandyke or brown print. See also *Blueprint, brown sepia print.*

Mylar technique See *Screenless photo-printmaking.*

Nonsilver photosensitive printmaking This includes the gum and platinum processes.

Palladium print The sensitising and printing procedures for palladium are virtually identical to those for platinum; palladium is simply a slightly less expensive metal and gives permanent brown-toned prints.

Photo-etching techniques Autographic photo-etching refers to darkroom chemical process in which a plate coated by hand with a photo-resist is exposed to a light that hardens parts of the plate; a film containing an image allows the positive (or negative) parts of the image to remain soft. These are then washed out and the plate is bitten in the acid.

Photogravure This is the term for the commercial application of the intaglio process. Machine printing of intaglio images was made possible by the invention of a crossed-line screen—already familiar in halftone blocks for relief printing. In gravure printing, the block is divided into tiny, squarish pits, each of a different depth. The image is photographically transferred onto a cellular structure in which etched hollows of regular area but varying depth dictate the amount of ink carried and printed. The plate is coated with thin ink and the top surface wiped clean with a soft blade. Gravure printing had many more commercial applications than

other methods, because the intaglio cylinder is very hard-wearing and the paper used is cheaper than the coated papers required by relief printing or offset lithography. It is still found in use commercially, but is little used by artists today. It is also called line photogravure, aquatint photogravure, sand-grain photogravure, and rotogravure. (See also *Collotype*, page 54.)

Photomechanical Any process in which an image can be photographically translated into one of the print media—for instance, line block, halftone, photo-litho, photo-screen, photogravure, and so on.

Platinum print This is a process in which the paper is coated with a sensitised solution, exposed to light, and developed. The image that is left consists of a metallic platinum in a finely divided state; this enables the process to register the tones of a photographic negative with remarkable delicacy. It is often done on fine-quality, mould-made matte paper. The colour of the image can range from brown to warm black.

Posterization Often regarded as an alternative to halftone printing, posterization is widely used in screenprints. The gradation of tone in a photograph is analysed by several varied time exposures in a camera into a series of distinct tones: light, mid, and dark. Each is made into a separate screen and printed in sequence, light tone first. The effect is a series of halos that give the impression of a continuous gradation of tone. Both systems are used for monochrome and coloured prints.

Process darkroom A darkroom with facilities for the production of photographic images for printmaking—for example, various types of line and halftone negatives and positives; colour separations; exposure units and cameras both for making negatives and positives; coating plates and screens; exposing stencils; and so on.

Screenless photo-printmaking Today there are many new inventions using photo techniques without the use of mechanical screening techniques. These include a range of new techniques using tonal drawings made by artists directly onto a drafting film with a very fine grain; the drawings can then be transferred with great fidelity to a sensitised plate or screen. Kip Gresham of Gresham Studio in Britain has pioneered work with a film called True-Grain; Mylar is another drafting film in current use.

Extensions of this include artists drawing their own colour separations in the colour they wish to print; these are then easily laid over each other to allow the buildup effects to be illustrated before printing. Laser-generated and computer photo-work will extend these techniques indefinitely.

Woodburytype Walter B. Woodbury patented this method in 1864. It involves printing from intaglio moulds—using a photographic image, creating a gelatin relief surface of the image, impressing it into soft lead, filling the impressions with pigmented gelatin, and impressing again, to create a "woodburytype" on paper.

LETTERING AND WORDS

The term *lettering* is used to refer to any printed letters (type or typography) on a print. (Manuscript annotations are referred to as inscriptions.) In the past, the lettering on an intaglio or relief block or plate was usually entrusted to an engraver. Wooden typefaces and lead fonts have all fascinated artists who want to work with words. Words have long been a form of artistic expression; this has been perhaps taken further by conceptual and concrete artists' use of written language to create prints in which typographical emphasis makes the poem or statement into an object rather than a song. Photomechanical options have increased the possible ways of utilising typography in printmaking and more recently, computer-based technology has begun to offer the artist every possible option.

Typography The art and technique of working with type.

Typographer In the United States, this means "one who sets type" (that is, a compositor); in Britain, it is taken to mean a typographic designer.

Typesetting Typesetting has long been part of printing. Originally, it involved wooden hand-carved blocks; this was the first attempt to create movable cast type. Hot metal took precedence until, in recent years, computers offered instant typesetting systems.

Letterpress A printing process in which the impression is taken from the raised surfaces of type matter or of blocks (relief print).

THE PRINT IN BOOK FORM

Book art is conceived and made by an artist and may take diverse forms, varying from the wholly visual to the solely textual. Book art is often privately published by the artists themselves; the content often includes poetry, images, philosophy, autobiography, narrative, political text, even performance documentation, and so on.

Book art employs numerous hand- or mechanized-printing techniques and can also include originals—watercolors, photographs, drawings, etc. It is published in one-offs, limited editions, or editions ranging from a few hundred to unlimited multicopy publications.

THE PRINT AS CAST PAPER

Fine-quality paper has long been a hallmark of good prints, and paper plays an essential and inherent role in printmaking. However, artists have been involved in making art *in* (not *on*) paper since the early 1960s. Americans have led the way with amazing inventiveness. As paper has itself become a print (so called because of the option to make an edition of paper pieces), artists have become more directly involved in the process of creating it. Ken Tyler took Rauschenberg to Richard de Bas where the galvinized metal cookie-cutter moulds were first used; *Pages and Fuses* did much to make this art form better known. Many print workshops and papermakers have combined forces in the last thirty years to push the boundaries of papermaking and printmaking: Ken Tyler and papermaker John Koller collaborated to make an acrylic-mould system in order to maintain unique shapes and areas of colour; Frank Stella's paper reliefs were shaped, hand-sewn moulds dipped in a vat of pulp and dried on the mould, produced at Tyler's workshop and, again, where landmarks in the editioning of paper works. There is an array of techniques for patterning and colouring pulp, spraying, stenciling, and pouring, as well as for creating embedments or layers of colour, making embossments, casting freehand, and any form of manipulation. In this book, we remain directed toward the paper pieces that can be editioned.

An Alphabetical Guide to Paper Techniques

Cast paper print The pouring of wet pulp into a specially made mould; when dried, it will form a paper work. This pouring can be done into its own mould or laminated onto cloth or paper. Paper pulp can also be poured directly into a plaster, composite material, or plastic mould and retrieved when dry. The thickness of the layer will depend on the overall size of the cast; the larger the size, the heavier the paper usually is. Coloured dyes and pigments can also be added to the pulp. Many pressed paper/pulp works are editioned. Varient editions are also made in which variations occur in an aspect of the work.

Coloured pressed-paper pulp A term referring to the use of dyes or dyed pulps in the making of unique handmade paper forms.

Moulded paper A sheet of paper that has been shaped and dried around a form.

Poured pulp See *Cast paper print.*

Pulp spraying technique This often refers to the spraying of pulp over a three-dimensional armature.

Vacuum papermaking technique A technique to make shaped sheets of paper by dipping a shaped mould attached to a vacuum system into a vat of pulp. Most vacuum systems work by utilising atmospheric pressure to compress a layer of pulp, thereby extracting water from it.

THE PRINT AS A THREE-DIMENSIONAL FORM: NEW AND EXPERIMENTAL MEDIA

An expanding range of media such as acrylics, urethane foams, polyesters, metal, and lead can today be formed; because these process are repeated and often editioned, the results may be classified as original prints. The range of experiments over the last thirty years has been vast, led mostly by the American print workshops, whose inventiveness and creativity has known no boundaries. Different technologies have

often inspired artists; Ed Keinholz working at Gemini used a familiar material in a new way—a car door serves as a base for his *Sawdy* series. The Institute of Experimental Printmaking with Garner Tullis pioneered many new approaches, including lead embossments. Jasper Johns's lead embossment *High School Days*, made at Gemini, presents a memorable image of *Lead Relief with Mirror Inset.* Plaster, latex, and rubber moulds are used to make castings of pourable resins such as polyester and epoxy; metal casts—bronze sand castings, aluminium—anything can be used to present the artist's aim. Jim Dine's *Tool Relief* was made in cast aluminium, and *A Plant becomes a Fan* is a five-piece multiple, cast in aluminium and hand finished.

In the name of experiment, images have been printed onto every possible surface—flat or three-dimensional—whether plastic, metal, ceramic, or fabric. Prints have incorporated embossing, collage, flocking, and metallic-film blocking, and have been of any and every shape—circular, square, irregular. Many of these prints will be ephemeral, as the materials' ability to withstand the passage of time is untested.

Installations Artists, seeing the creative potential in ordinary items, such as trash cans, bollards, and bus shelters—and in the not-so-ordinary, such as bubbling chocolate, sheep heads, urine, chewing gum, and blood—have departed from known practices for the creation of other spaces and experiences. These "experiences" which are often temporary and deteriorating, represent one of the newest forms of current expression. This form of statement can provide a refreshing and unpredictable perspective from which to view art. Although it is not usually connected with any form of original printmaking, some of the artists produce documents of the experience in the form of printed matter.

ELECTRONIC MEDIA

Printouts from computers and photocopying machines, sometimes described incorrectly as photo-litho or even photo-screenprints, represent an exciting new trend. One invention now being relatively widely used by artists (which shows signs of increasing popularity as its capabilities improve) is that of electrostatic printing—commonly known under the trade name of Xerox, but including printing from other office copying and printing machines such as small offset-litho and stenciling

machines. Electronic media have given artists the capacity to use image making—especially photography—in extremely flexible ways. Today, many printmakers are utilising the computer and its software, output printers, and the photocopier for part or all of the process of image-making. Although these processes and their use by artists are still in their infancy, they lie within the definition of planographic printmaking. It is worth noting that the paper utilised in many of the regular machines at present is not permanent and will rapidly deteriorate; there is also some concern about the permanency of colours.

An Alphabetical Guide to Electronic Techniques

Colour in electronic output devices To a greater or lesser degree, all of the organic dyes used to form images as output from a computer gradually fade when exposed to light. In long term display, no current material with a dye image is permanently stable. Recent developments with the use of pigment instead of dyes have produced a colour process with extraordinary light-fading stability. New developments take place continuously. The inevitable outcome will be that images will be stored and viewed on computer and never issued on paper at all!

Computer image processors The artist has a wide choice of computer equipment suitable for use in visual expression. *Hardware* is defined as the central processing unit, keyboard, monitor, and printer; *software* consists of the instructions in computer language that tell the hardware what to do—and an ever-increasing number of sophisticated programs exists. Imagery can be put into a computer by drawing on a digitized tablet or by drawing with a mouse. Other methods of input of visual images include scanning, videodigitizers, and optical character recognition software. All of these systems allow the computer in one way or another to translate artists' images into electronic codes that can be used and stored on disk.

Computer output devices There are two basic ways to transfer an image from a computer screen to a printmaking medium. The first is by means of a computer printer—daisy wheel, dot-matrix, pen plotter, ink-jet, thermal, laser, and so on, in colour or in black and white. The second

is taking a photograph from the screen or from an internal film recorder. Both of these processes turn impulses from a computer into dots on paper. The printers listed above are not usually designed for high-volume production or long printing runs, but the range of opportunities is continually expanding. New developments in computer-generated imagery have also led to other new services such as computer-produced film for separations; computer-controlled stencil-cutting machines; computer-controlled armatures for lino cutting; metal engraving; and more.

Computer printers include:

1. Daisy wheel printers. These are really designed for type characters, and are generally too crude for graphic images.

2. Dot-matrix printers. These work by impacting small pinheads onto a ribbon and then onto paper to form a character or image. Evidence of the pattern can be easily seen with the naked eye.

3. Thermal printers. These are related to the dot-matrix printers in that they use a pin system; the thermal printer heats the pin, which then melts a waxy ink from a ribbon onto paper. This type of printing produces more vivid colours than does dot-matix, and is perhaps even the strongest of colour printers. Its drawbacks include the question of colour fastness and the requirement of special papers.

4. Ink-jet printers. These fire ink through miniature nozzles.

5. Laser printers. This is an electromagnetic printer, similar to a copier. The laser printer draws on a negatively charged drum, which in turn becomes receptive to the toner ink. The drum rotates and comes into contact with positively charged paper. The toner is transferred and fused with heat and pressure. It is available in black and white and in colour. Resolution can vary from 300 dots per inch to the Linotronic, which can print 1270 dots per inch.

Fax printing The fax machine is one of the latest technologies to be hijacked by artists. Again, the results from usual technology are transient—but permanent and acid-free papers are available for these machines.

Xerox The widely familiar electrostatic printing (or xerography) is a process in which an image is made when dustlike grains of black are attracted to charged areas of an electrostatic field and then fixed by heat. Colour xerography has been used by artist printmakers as the final process for a print; here the powdered, melted, and hardened colour has a sort of enamel-like quality.

Xerox transfers Editions of prints have been made by transferring the images with either black-and-white or colour Xeroxes. This technique employs the soaking of a Xerox in acetone and rubbing it from the back onto a fresh sheet of paper.

Comparison of Printmaking Techniques

Common name of print	Woodcut Wood engraving Linocut Found object	Etching Engraving Aquatint Drypoint Mezzotint, etc.	Lithograph Stone lithograph Plate lithograph Mixed media	Screenprint Serigraph Silkscreen
Materials used	Plank wood, end-grain wood, lino, found objects	Copper, steel, zinc, plastics	Limestone blocks, zinc, aluminium, paper plates	Silk, nylon/polyester material
Basic tools	Knives, V- and U-shaped gouges	Burin, etching and drypoint needles, rocker, grounds, acids	Greasy (litho) crayon, tusche, inks	Squeegee, stencil material
Type of press	By hand pressure, or with a barren, Albion, or columbian press, a letter-press-type press, a blocking press, or a bookbinder's press, hydraulic platen press	Etching press, copperplate press; hydraulic platen press	Litho press—indirect or direct press, hydraulic platen press	Screenprinting frame a bed, vacuum bed
Printing surface	Surface of a block of wood or linoleum	Copper, plastic, or other metal plate	Litho stone or metal plate	The screen gauze or material
What prints	Surface of wood or linoleum	The ink in the grooved depressions and/or the plate surface	The greasy image that marks the surface	The open (image) area of the mesh
What does not print	Grooved depressions	The top surface of the plate	The unmarked surface	The blocked areas of the mesh
Type of pressure	Direct and heavy pressure from on top only, or squeezing pressure through one or a set of rollers (wringer-type), or offset rollers; hydraulic platen press	Direct and heavy pressure downward, plus heavy squeezing pressure between the metal bed and top metal roller—horizontal pressure; hydraulic platen press	Downward pressure from on top plus scraper-bar horizontal pressure, or offset roller(s)	Pressure of squeegee covers screen includes horizontal pressure plus downward pressure at the same time

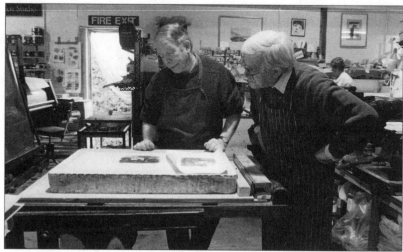

Photo by and courtesy Chilford Curwen Studio.

Stanley Jones (left) working on a stone lithograph at Chilford Curwen Studio, Cambridge, England.

The Artist
and the Process

Printmaking, like any other form of expression, is a way of forming a relationship with a creative process. It involves making marks, having ideas, working with them, revising, revisiting, and editing, allowing successive states until a final work is achieved. However, a print is not created in the same way as a painting or sculpture, mainly because of the intervention of a technical process between the artist and the support. The advantages of this intervention are many (outlined below) and in no way decrease the value of this art form.

Making a print certainly requires a skill: a form of technical expertise in one or many of the processes, and one that usually necessitates some form of training before it can be put to use. Some people term the skill of making a print a *craft;* indeed it is—historically, printmaking required a skilled craftsman to obtain a result. Artists who like to work in this way are skilled (often creatively) in a technique as well as in the creative process.

THE PRINT STUDIO

To produce any work in this medium, an artist requires use of a workshop set up specifically to perform skilled operations in one, several, or all of the techniques of printmaking. Various categories of studios exist, which are described in more detail below. The common elements any workshop offers are specialist knowledge of printmaking techniques and the availability of printing machinery and equipment that performs effectively—thus allowing the artist the best opportunities to produce original prints.

The vocation of "artist's printer" has long been in existence—the first printer to work exclusively for artists was probably French intaglio printer Auguste Delâtre, in the midnineteenth century. However, print-making studios set up specifically for artists to work in are a relatively new phenomenon. The first artists' studio in New York was the lithography studio opened by George Miller in 1917; Lynton Kister followed in Los Angeles in the 1940s. S. W. Hayter moved his famous Atelier 17 to New York in 1940, encouraging artists to share in the creative process and do their own printing. The phenomenon of artists (as distinct from printers who worked with artists) setting up their own print workshops followed and, by the mid-1960s, had taken seed.

To best describe the various types of printmaking workshops that exist today, I have divided them up by the different *approaches* to producing a print; on the whole the *processes* are universal.

The private studio

This is one of the more traditional ways of making an original print. The artist is creator and executor, often in his own private printing studio. For many printmakers, this involvement with the process, which can take years of apprenticeship, training, and hard work to learn, is essential to the production of the work. Many artist-printmakers welcome the discipline required to make a print and deliberately seek it in order to force themselves to clarify a train of thought or a half-resolved idea. For these artists, the physical involvement in both preparing the printing surface and actually printing it is an essential part of the creative process, and many artists like to do this alone.

There is, however, no fixed way of working. Some artists prefer not to make the edition themselves; to them, the repetition is a pointless waste of their energy, because the true excitement (and importance?) lies in the initial plate-making and proofing stages. The manufacture of the final edition becomes irrelevant.

The artist who works with a skilled technician

Working with a skilled artisan to achieve a finished piece of work is a collaborative process and one in which a creative interaction takes place at all stages. Although an original print is not produced in the same way as by an artist working alone, in this way of working the artist is experimen-

tally and creatively involved up to the B.A.T. stage (see page 93) and need not necessarily have mastered difficult printing techniques before being able to use them for expression. In this situation, an artist with little experience can employ the skills of others to create his works.

However, as in any such collaborative experience, the heart of the creative work is often the interaction of the artist and skilled technician—the very best of whom are called master printers. If temperaments are compatible, the printer will anticipate what the artist wants to do, suggest ways of doing it, invent if necessary processes hitherto untried, and generally contribute an enormous amount to the end product. It could be argued that few artists can keep up with the developments in the various media; only the experienced and knowledgeable specialists can remain abreast of the full range of new techniques, processes, papers, and so on. In many of these circumstances, the final work could not have been conceived without the printer. It is, in effect, the result of an intense and close collaboration.

A fine workshop and printer feed the creative instinct. An example of this is the series of etchings *The Artist and his Model*, which Picasso produced in seven months, from March to October 1968. The brothers Aldo and Pierre Crommelynck set up an etching press near Picasso's villa in the south of France and kept him constantly supplied with prepared plates; while he was drawing, they were biting and proofing the plates drawn the day before. Three hundred and forty-seven intaglio prints of great inventiveness were the result.

While master printers working with artists have played a crucial role for centuries, the 1960s have been marked by an enormous growth in this form of collaborative work. In a sense, the art of printmaking has been transformed from small-scale objects (kept in museum-stored solander boxes and requiring intimate study) to works that rival painting and sculpture in scale, technical complexity, and place of importance in many artists' oeuvres.

The professional workshops in the United States have played a prominent role in this development, especially in the past four decades. Bolton Brown and Margaret Lowengrund were instrumental in this. Her second workshop was eventually to become the Pratt Graphic Center. The year 1957 saw Tatyana Grosman start Universal Limited Art Editions in the garage of her home. In 1960, June Wayne opened the Tamarind Lithography Workshop in Los Angeles (which moved to the University of New Mexico in Albuquerque in 1970 and changed its name to Tamarind Institute). The purpose of this workshop was to train printers in the techniques of lithography so that artists from all over the U.S. would have access professionally

to that medium. Workshops owned or run by Tamarind-trained printers have been an inspiration to many. Other well-known professional workshops, such as Gemini GEL on the West Coast, Tyler Graphics on the East Coast, and Landfall Press in the Midwest, have worked with myriad artists in the last forty years to create great prints of grandeur and inspiration. Publishing workshops have also opened at a number of university campuses. Graphicstudio at the University of South Florida in Tampa needs a special mention as—although it has had a chequered career (almost totally closing in 1976)—in the past decade it has produced some of the most daring prints and sculpture of the period.

Professor Pat Gilmour states, in an article for *The Print Collector's Newsletter* (Vol. XVI, No. 5, Nov.–Dec. 1985), that

> *Despite this interdependence (the artist and printer) and the fact that without such a partnership some of the most successful prints in the world would never have come into being, history has a way of recording, and therefore remembering, only the name of the artist. . . .*

British master printers instrumental in changing the face of printmaking in the United Kingdom include Chris Prater at Kelpra Studios, Stanley Jones at Curwen Studio, Chris Betambeau at Advanced Graphics, and Brad Faine at Coriander Studio, amongst many.

Open-access studios

The third way for artists to produce a print is to work in an "open" studio—a communal workshop, termed currently in Britain "open-access."

Artists have been involved with printmaking in cooperative studios, such as the famous Hayter's Atelier 17 in Paris and such centres as the Pratt Graphics Center in New York, for many years. In Britain, Birgit Skiold set up the first "artists' print workshop" in Charlotte Street in London in 1957; it attracted a wealth of international artists.

Open-access studios represent a wide range of attitudes but are united by the fact that they open their doors to any artists who wish to work in a communal atmosphere. Because the costs are shared by all who use the workshops, they are a cheaper alternative to working alone or with a master printer. Especially well known in Britain are the Scottish group which includes Glasgow Print Studio, Edinburgh Print Workshop, and London Print Workshop.

MAKING THE PRINT

The attraction of the individual printmaking techniques is very real for the artist. There is also considerable magic in the printing process itself: laying a virgin sheet of paper onto the plate, applying pressure to transfer the ink on the plate onto the paper, and peeling off the paper to reveal the design, are physical activities that can, in themselves, be exciting. Even if the same action is repeated with a hundred sheets of paper for an edition, for some the magic is still there. The physical involvement in both preparing the matrix and actually printing the edition is essential for many artists.

Printmaking follows a regular if loosely defined sequence dictated by its processes. There are several key stages in making a print, and they are common to all the printmaking processes:

First Stage

In this stage, the idea of the work begins. Plans can be made by the artist in or away from the workshop or studio. He may come into the print studio with an idea already present in his mind or on paper, from which the original work develops onto the plate, block, or screen; or he can, either on his own or in collaboration with a printer, work directly with the medium and allow the print to emerge and develop autonomously.

Second Stage

Drawing on and experimentation with the actual image on the plates, screens, or blocks occurs, followed by colour proofing and final proofing. Many types of proofing stages exist (see page 93). Proofing is looking at a particular state of the image on paper and making any necessary changes. This stage of work reaches completion with the printing of a final proof acknowledged by the artist with his signature (commonly known as B.A.T.; see page 93).

Third Stage

The final proof agrees what the edition should look like. At this third and simply technical stage, the edition (or part of it) is printed by the artist-

printer or printer-technician. In the latter case, the artist is not required to be present.

Fourth Stage

This stage encompasses all the finishing stages of making the print—drying, cleaning, trimming, approving, and final signing. When the edition is completed, the plate, block, or screen is canceled and the printer takes a print from it. This is also the time for collecting and either discarding or signing the proofs as well as the edition. The artist's signing of the prints authenticates the print and completes the finishing processes. The print studio may also chop mark (see page 99) the print at this stage. Distribution then takes the print to gallery, publisher, dealer, buyer, and so on.

THE IMPORTANCE OF PAPER

The traditional way to make paper is to beat rags into a liquid pulp. The hand papermaker scoops a tray of crossed wires into this mixture of liquid pulp and water; a thin layer of fibres settles onto the wires. This is then turned out onto felts, the water pressed out, and the sheet dried. To turn a sheet of paper into printing paper, it often has to be sized or sealed (though not for all processes).

One of the qualities of paper that allows it to exist over centuries is its degree of purity. This is the quality most often discussed by artists, conservators, and museums alike. "Is this paper permanent?" is a question often asked. So many factors can contribute to the deterioration of a sheet of paper that it seems essential, if it is to be the only support of a piece of art, that it start life in as pure a form as possible. The presence of acids in paper has been shown to seriously contribute to its deterioration; consequently, a paper claimed to be "acid-free" has become desirable. Much information about acidity and pure papers is contained in chapter 7, Caring for Prints, but a few general facts about paper are not amiss here.

Information about paper

There are actually only three basic types of paper in general use today—handmade paper, mouldmade paper, and machinemade paper. The type of

paper that each individual artist or workshop will select is a matter of personal choice, but the paper will have an essential role to play in the success of the work—both in the way it performs and the aesthetic point of view.

Handmade papers Handmade papers today come from small mills all over the world whose processes are truly individual. The sheets are made on a small scale compared to other papermaker's techniques; the forming of the paper takes place by hand often in an age-old, traditional manner. The papers can be astonishing in their beauty and available in a multitude of different colours, weights, shapes, and sizes. Recognising where an individual piece of paper has been made is difficult but clues do exist. Most "Western" papermakers have their watermarks in the paper. Asian papers are the most difficult to recognise. "Washi" is a very important part of today's papermaking both in Asia and America. Easily spotted today are flower petal inclusion sheets, such as those from the Richard de Bas mill in France; brightly coloured, textured papers from India; special sizes and shapes from the Twinrocker (U.S.) custom makings; and the very fine, white, and luminous papers from Japan. It is often necessary for artists to contact the mills; current distributors stock few handmades compared to the number of mills that exists. If a special paper has been used in an edition, perhaps the papermaker was local, the artist (or publisher/printer) has a special relationship with the papermaker, or the artist has visited the mill and was excited by a particular area of sheet making.

Mouldmade papers Although the basic process of papermaking has remained unchanged for two thousand years, machinery has now usurped much of the hand work formerly carried out by craftsmen. The two basic *machine* methods of papermaking utilise either a Fourdrinier or a cylinder mould machine and are responsible for today's production of paper in a continuous web. The cylinder mould machine makes what are termed mouldmade papers—which today are extensively used for the printing of editions. The paper made on these machines closely resembles handmade paper; the initial pulp preparation is the same, right up to the formation of the sheet. At this point, the slow-running machine takes over the hand jobs of the vatman, coucher, and layer.

Mouldmades are probably the most popular papers in use today for printmaking, because they are even, stable, and consistent.

Mouldmade papers that are well known and widely used today include *Arches 88*, *Arches*, *En Tout Cas*, *Velin Arches*, *Velin BFK Rives*, *Moulin du Gué*, *Velin Pur Fil Johannot*—all French mouldmade papers from Arjomari; *Lana* papers come from the Vosges area of France; *Bockingford*, *Somerset*, *Saunders*, and *Waterford* are British mouldmades from the Inveresk mill; *Whatman* papers are made near Maidstone in Kent; *Fabriano* papers, such as *Artistico*, *Murillo*, and *Tiziano*, are mould-mades from Italy; *Guarro Casas* are mouldmades from Spain; *Hanemühle*, *Schoellershammer*, and *Zerkall* mouldmade papers come from Germany; and *Schut* mouldmade papers come from the Netherlands.

Machinemade papers These papers represent the cheaper end of the paper market. They are manufactured in quantity for mostly industrial and commercial uses. Their properties, processing, and ingredients vary according to the uses to which they are to be put. However, there are some fine acid-free machinemades used for printmaking.

Watermarks

Often a paper can be recognised by its watermark. Watermarking was a very early device that helped to identify the name of the paper and the mill where it was made. A watermark is actually a variation in thickness introduced as a sheet of paper is being made; it looks like a raised design in wire attached onto the metal mesh of the paper mould. As the papermaker pulls the mould immersed in pulp slowly out of the vat, fewer fibres remain on top of the raised wire watermark than on the mesh as a whole. When a dried sheet of paper is held up to the light, the watermark is clearly visible, because the paper in that area is thinner than it is in the rest of the sheet.

A watermark gives information about the paper, the mill, or even the artist. Often, a publisher or an artist will order a special paper for making an edition—one with a unique watermark device. Watermarking of special editions has been traditional over the centuries, and the study and identification of artists' papers has merited special attention.

The Publisher's Involvement

Publishers are often crucial to an artist's development. They work in partnership with artists and together share and solve many problems.

Ambroise Vollard is a particularly important example of a publishing figure—an illuminating example for many contemporary followers. Between 1900 and his death in 1939, he almost single-handedly set the role model for contemporary publishing. He simply encouraged artists to make prints. He was among the first to understand the greatness of Cézanne, to discover Van Gogh, and to invest in prints with a considerable proportion of his income. Most of his publications were elegant and sumptuous illustrated books, and he commissioned artists of the stature of Bonnard, Picasso, Chagall, Rouault, and Dérain, among many others.

A publisher's role is, at best, to act as a catalyst, matching artists with printers and often financing the whole process. With a genuine love of art, a good publisher will see the potential of an artist and give him the opportunity to experiment—something that might not have been possible without such active support. It is essential that an artist's genius be backed by what may be considered the talent of another person who knows how to appraise the work and give encouragement and help. In this age in particular, there seems to be an increasing need for the kind of intelligent publisher who is able to advise and help the artist. In Britain, there has been important support for artists from such publishers as Editions Alecto, Petersberg Press (now closed), Curwen Prints, and The Paragon Press, as well as gallery publishers such as Waddington Graphics, Alan Cristea Gallery, and Marlborough Graphics.

In the last few decades, there has been a proliferation of printers who have also turned to publishing and dealing. This has encouraged the production of complex and often glorious prints, works that, with great creativity, have found new solutions for a host of expression questions. Examples of "publishing" workshops in the United States include Tatyana Grosman's Universal Limited Art Editions; Ken Tyler's Tyler Graphics; Crown Point Press with Kathan Brown; the Garner Tullis Workshop; Derriere L'Étoile Studios with Maurice Sanchez; Solo Press with Judith Solodkin; Landfall Press with Jack Lemon, Donald Saff, and Deli Sacilotto of Graphicstudio in Tampa, Florida; Gemini GEL with Stanley Grinstein and Sidney Felson; and Cirrus Editions with Jean Milant. There are also many others who have been primary influences.

In Britain, "printer" publishers include Chris Prater of the Kelpra Studio (now closed), Brad Faine of Coriander Studio, Bob Saitch of Advanced Graphics, Stanley Jones of Curwen Chilford, Kip Gresham of Gresham Fine Art, Alan Cox of Sky Editions, and Bernard Pratt of Pratt Contemporary Art.

How To Recognise the Authentic

I n the middle of this century, the method by which a given print was executed could be fairly easily classified. Today, when a finished work is often more technically complex than its predecessors, it is quite difficult to recognise or separate out the processes involved.

Terminology: Modern Prints

From a historical perspective, *modern* prints are generally regarded as those produced from about 1800 onward. Technically speaking, modern printmaking began only in the second half of the nineteenth century—quite a long time after the technique of lithography had been invented—when the means of steel-facing copper and zinc had been developed, allowing artists to print large numbers of impressions of uniform quality.

Terminology: Contemporary Prints

In this book, *contemporary* refers to prints made within the last three to four decades, the time when the most important artists of our period devoted much of their creative energies to the print media; when printmaking set off along a very inventive and exciting period in its history. Hayter, working in Paris, gave new life to intaglio printing; the revival of lithography started around the early 1960s, and screenprinting had almost

broken into flower by the late 1960s. Technological advances offerred unlimited scale, so that the size of works could rival that of paintings. Photography held a key place, offering artists of all stylistic movements totally new opportunities; major new influences were news and commercial graphics. Most recently, the accessibility of the computer and electronic media has offered a new dimension to printmaking.

HOW TO RECOGNISE AN ORIGINAL PRINT

One of the surest and most effective ways to recognise a "regular" original print is to refer to its certificate of authenticity. In several countries, laws aimed at preventing fraud require certificates to be issued with each published print. In such a certificate, you will be informed of various specifications of the work you are buying and should expect details such as the title, technique, type and dimension of the supporting paper, size of image, quantity of the edition, number and types of proofs, printer, publisher, and—often—a description of the making process. Presentation of this kind of information can only increase a collector's involvement and can add much pleasure to buying a work.

The support

Before we begin to look at the characteristics of each medium, a note about the support. Traditionally, a print was a work of art made on paper. Since the 1940s, artists have expanded their creative approaches to the print, and exploited many new materials that are capable of receiving an impression. Thus, prints can often be found on supports other than paper. The *printing surface* refers to any material subjected to the artist's intervention; most printing surfaces will withstand more than one impression.

The Nature of Printmaking

As we already appreciate, the nature of the print with which this book is concerned is that of an original work of an artist using the medium of printmaking. Original prints possess certain unique qualities that

TYLER GRAPHICS LTD.
250 Kisco Avenue
Mount Kisco, New York 10506
914-241-2707
914-241-7756 FAX

PRINT DOCUMENTATION:

ARTIST:	Frank Stella
TITLE:	*Swoonarie*, from the Imaginary Places
YEAR OF PUBLICATION:	1995
MEDIUM:	Etching, aquatint, relief, lithograph, screenprint
DIMENSIONS:	42" x 52" (106.7 x 132.1 cm.)
EDITION:	30
PROOFS:	12AP, 13CTP, RTP, PPI, PPII, TGLimp., A, C
PAPER:	white TGL, handmade

PRINTERS: Papermaking by Tom Strianese and Robert Meyer; prep work of artist's materials and collage by Kenneth Tyler; copper plate preparation and processing by Anthony Kirk; woodblock preparation by Kirk, Susan Hover, and Yasuyuki Shibata; magnesium plate preparation and processing by Swan Engraving; preparation, proofing, and edition printing of assembled plate by Kirk, Brian Maxwell, Hover, Shibata, and Kathy Cho; screen preparation, proofing, and edition printing by Michael Mueller; aluminum plate preparation and processing by Lee Funderburg; proofing and edition printing by Funderburg and Kevin Falco

SIGNED: *F. Stella*, numbered, and dated in pencil lower left; chop mark lower left; workshop number FS94-3087 lower right verso

DESCRIPTION: An original 39 color etching, aquatint, relief, lithograph, screenprint on white TGL, handmade paper printed from 1 screen, 5 aluminum plates, and 1 assembled plate made from 1 base woodblock*, 12 irregularly shaped crushed metal plates, 23 irregularly shaped magnesium plates, and 9 irregularly shaped copper plates.
*The woodblock was made from 2 wood panels adhered together. Wood was selected as a base because the crushed metal plates were of irregular thickness. The wood was carved to accommodate the various depths of the different plates. The block was inked and printed as a relief.

We the Undersigned declare this information to be accurate.

Artist: _____ Director: _____ Date: May 1995

© COPYRIGHTED TYLER GRAPHICS 1987

Photo by and courtesy Tyler Graphics, New York

The print documentation of Frank Stella's print *Swoonarie,* produced on publication by Tyler Graphics, 1995.

form their identity. As every printmaking process has its own individual characteristics, only a single print need be examined to ascertain how it was produced. Also, the way a particular artist utilises a technique, or expresses his ideas in print, may well point to identification of a certain period in that artist's oeuvre.

How to Identify a Relief Print

Relief printing has a strong character. It can be recognised by the qualities of the incised line and often by the way the printing lies on the piece of paper.

1. First, if you look on the back of the paper of a relief print you may be able to distinguish the slight embossing mark of the block—not a definite plate mark, as in intaglio, just a light indentation caused by the edge of the block.

2. Look on the back for a slight sheen to the image area where hand burnishing has taken place.

3. Look at the print and the quality of the printed line. In a linocut or woodcut, the nature of the line is that of a sharp, cut mark that has none of the qualities of a hand-drawn mark, although a smoothness and fluidity may still be apparent.

4. Cutting is a key to recognition of a wood- or linocut. Of all of the techniques in printmaking, the woodcut is least suited to tonal work. A woodcut is a block cut on the end grain of a piece of wood (engraving) or a block cut on the plank edge (woodcut). Wood engravings offer opportunities for detail and fineness of line that are not possible on the often coarse natural grain of a piece of wood. Wood engravings take away parts—which are then left to be printed as white areas—whereas woodcuts are simply incised into the wood, leaving the line white. It is common for wood engravings to be small in size because end-grain wood is only available in small pieces. To make large wood engravings, blocks are jointed together. A line seen as a white gap in the print is a common recognisable feature.

5. Looking at the printing, there is an almost unmistakable way in

which the pressure of an inked block, either of a large area or a thin line, leaves a "rim" (a buildup) of ink around the outline of each printed area. Find the edge of an image and look at it through a magnifying glass. Some people describe this quality as "squashed" ink, but I prefer to think of it as the place where the thick ink tips over the edge of the printed block and splays out a little. If the block is inked dryly, this characteristic buildup is not quite so apparent.

6. Colour in relief or woodcut has its own characteristics. The broad effects of flat colour printed from plank wood often reveal the wood grain or give an "unsteady" edge to a shape or colour area. Areas of colour on a woodcut, card print, and so on will often fit together like a jigsaw puzzle, whereas a colour wood engraving is likely to have colours printed underneath united by a black key line over the print (easily identifiable in Japanese prints).

7. Frottage, potato prints, and other simple-process prints are fairly easy to recognise; you may well have already done so yourself. The wax or pencil scribble over an object that allows its reproduction onto the paper is well known. However, impressions from rollers and prints taken directly from objects themselves are more difficult to identify with certainty. Relief printing has neither the acute detail of a photograph nor its mechanical translation into tone. The relief print is an impression of surface characteristics—often as flat colour—and has a characteristic thick ink with a slight sheen to the surface.

How to Identify an Intaglio Print

1. The plate mark, so characteristic of any intaglio technique, is the line of indentation in the paper where it was pressed against the edges of an intaglio plate; it is viewable from the front of the image. It is one of the most obvious features of an intaglio print. One can often identify the beveled angle at which the plate was filed; the reason for this bevel (or for filing the edge of the metal plate to an angle) is that it prevents the paper from being cut by the very sharp edge of the metal plate during printing.

2. Sometimes prints made by the relief, screen, or lithographic methods are impressed with false plate marks, usually with the intention of passing them off as intaglio prints. To identify a print as *not* an intaglio, look for the the image areas to have *no* relief to them.

3. The process of putting ink into grooves (or images), and printing by forcing the damp paper into those grooves, results in an embossed relief that you can feel and see quite easily on any intaglio print; the grooves, lines, and areas of the image all stand up in relief from the paper's surface. The back of the paper, too, will show these indentations.

4. The intaglio method leaves a very dense deposit of ink in the deepest lines—a thick, heavy, rich, luscious amount of ink that almost looks as if the line "bubbles" with it. This is a quality of intaglio that is common. The plate, however, is capable of printing more than one level of ink, so the depth of the embossing (or raised parts) can vary.

5. Embossing is a natural effect of the intaglio process, and if very heavy pressure is placed on the paper while printing, the paper is extended and stretched into the heights and depths of a plate—giving a sculptural quality to the print. These prints are often made without ink and are called blind embossings.

6. The only truly solid areas of black in intaglio are made by the mezzotint method. Blacks made by other methods in the intaglio group are made up of either layers of marks, such as crosshatching, or etched parts of the plate.

7. The clean or white parts of an intaglio plate occasionally have scratch marks, which, if not wiped very clean by the printer, will show on a print as 'polish' marks with very thin, fine deposits of ink.

8. The tools of the intaglio processes each have their own characteristic marks. A drypoint is a very hard, sharp-pointed needle that scores the surface of the copper—the marks are often of a harsh, sharp, unflowing nature. In making lines this way, a burr is created, which is sometimes scraped off. However, when the burr is left on, it retains the ink so that, when printed, a very delicate velvety shading to the edge of the line occurs that is quite unmis-

takable and specific to this process. For engraving into metal, the burin, a V-shaped tool, is used. As it starts to cut into the surface of the metal, there is a thinness and lightness to the mark; as it progresses and grips the metal, the cut gets deeper. Therefore, engraved lines tend to be pointed at each end. The character of the cut line—and those produced by any cutting tool—has been described as "mannered" and "inhibited in character" and not a free hand-drawn mark. Stipple-etching provides a variety of stipple-effect dots that are farther apart in pale tone areas, and heavier patterned in darker toned areas; the technique is close to that of halftone screen but without its very regular patterning. It is often done with a tool called a mattoir or macehead. Because of the way the plate is made—with a crosshatched pattern of indentations—the mezzotint supplies the richest, deepest, and most velvety blacks of all intaglio (and even printing) processes. If any confusion between this and any other intaglio blacks occurs, refer again to the depth of the black. A roulette is a drawing tool made up of a series of small dots; it rolls over the plate, puncturing the surface (often of a resist or ground). With it, a soft line is achieved rather akin in effect to a chalk drawing.

9. In an etching, the quality of the needle (or any other tool) taking away the wax ground or resist on the surface of the plate tends to be less formal than that of engraving techniques in intaglio. Bamber Gascoigne poetically suggested that recognising the difference between an etching and an engraving is "to imagine the surface of the paper as a thin layer of snow on a frozen pond. The engraver is limited to making lines with the edge of a skate; the etcher can draw with a pointed stick." In a soft-ground etching, an artist may draw into the soft ground with a pencil, and the quality of the line reflects this ease of drawing. Unless you can spot the raised manner of the intaglio line or plate indentation, you may confuse the results of this process with a chalk-drawn lithograph.

10. An aquatint is recognisable by the grainlike pattern discernible in the image areas. Usually it consists of a network of irregular-sized, small, white areas surrounded by black ink (the opposite of mezzotint). The varying types of aquatint have different characteristics: for instance, collotype—very fine grain; dust grain—erratic with large or small particles.

11. Colour in intaglio prints is recognisable often simply by identifying the number of different plate edges at the side of the print (one plate for each colour). In a multiple-plate printing, the inks overlap each other; in a viscosity printing, the colour is at different levels in the plate. In à la poupée, inks are put into adjacent areas on a single plate in à la poupée style; the process is often clearly identifiable by the way an ink will mix with the next colour at the edge of the colour area.

How to Identify a Lithograph

1. In a hand-drawn lithograph, no matter what quality was used to make the drawing—using a pen and ink, crayon, wash, and so on—the marks will be faithfully reflected by the print, lying very thinly and flatly on the paper. Should the litho stone have a rougher quality, the resulting print will also reflect this in its printed lines. In lithography, the black is quite distinct—dense but never heavy.

2. The wash effects of lithography—drawing on a plate or stone with grease diluted by water, called tusche drawing (or litho tint)—are very akin to those of a wash drawing or watercolour, and unlike those of any other printing technique. They are so exquisitely light and delicate only lithography could offer them. It is claimed that the newly developed techniques using True Grain (or similar) films in photo-screenprinting can offer the same or similar effects, but, in my opinion, they do not truly match the lightness and beauty of a litho wash.

3. It may be more difficult to distinguish a screenprint from a lithograph if the image is in areas of flat colour. Lithography and screenprinting have in common a flatness of ink. Looking at any colour print, the absence of any relief or intaglio characteristics obviously indicates either screenprinting or lithography. However, even in a colour print simply of flat areas it is possible to recognise the separate character of each. A flat-colour litho impression will have a slight sheen to it, in which the colour lies very thinly on the top surface of the paper. In lithography, the inks mix easily when overprinted; when two colours are over-

printed, this gives rise to a third colour, and so on. Oil-based screenprinting, on the other hand, is the one process whereby you can mask an underlying colour with the top colour (although this colour can be extended to also be transparent). A screenprint leaves probably a heavier deposit of ink; however, the thin film inks recently developed for screenprinting leave a layer that is extremely thin but denser than a litho colour matte and stronger—akin, if anything, to paint. If you are looking at a print out of a frame, look for a solidity to the screen colour—it is often strong and identifiably matte and has a slightly porous effect (due to the fact that most contemporary screen inks are water based). Again, this characteristic cannot be produced by lithography, because of the nature of the process. Screenprinting also offers a very versatile range of colours—fluorescent, metallic, shiny gloss, extra matte, and others.

4. Dust is a hazard in litho printing. One of the ways I first recognised a lithograph was by spotting the "hickies"—little lumps of dust captured while printing, which created a small white ring in the middle of the solid black area in the print.

How to Identify a Screenprint (or Serigraph)

1. Because screenprinting and lithography can be confused with each other more than with other processes, comparison with lithography is often helpful (see above). In a screenprint, there is a dense, flat quality to the layer of ink; the colours are bright and strong. Subtlety is not an essential quality of screenprinting.

2. Colour can overlay and mask any underlying colour completely.

3. Paper is not always the primary support for a screenprint; one sign of screenprinting is that the print is made onto a surface other than paper (plastic, glass, metal, for instance). Fluorescent, glossy, flocked, and many other ink effects are also possible in this medium.

4. A "rainbow" effect—smoothly blending several colours on the screen and printing them evenly—is common in screenprinting. David Hockney's complex *Catherine's Walk* incorporates won-

derfully the essential beauty of both water-based screenprinting (note the blending) and lithography.

5. Fine detail can be printed in this medium, but not in the same way as in photo-lithography. The naked eye cannot often perceive the pattern of ellipses of a colour separation printed by gravure or offset lithography; you will, however, be able to clearly identify the separation of a screenprint.

How to Identify a Monoprint

Monoprinting has a swiftness, an immediacy, and a directness; the autographic quality of the medium is always in evidence. Particular characteristics are those of "squashed" ink, and that individual surface quality created in lifting the print from the glass. The monoprint has a direct, "painterly" quality that has its own look, which has been described as an "organic rightness."

How to Identify Hand Colouring

Hand colouring on a print is occasionally quite difficult to recognise, especially if you are not expecting it. Hand colouring can be achieved by any method—it may have the look of a watercolour wash—but the handwork will only really be apparent if you can compare it with other prints in the edition. Although it is possible to colour a whole edition in a similar manner by hand, each handworking is likely to be slightly different—even purposefully so.

How to Identify Photomechanical Media in Printmaking

Any printing of a photographic image which points to the use of a photomechanical (reproduction) process is often the most difficult to identify. Every image made today can be produced by photographic stencils, plates, or other means—even wash drawings. There is a move in many studios to make images via screenless photo reproduction means and often these are indistinguishable from handmade or handcut work, *except* in

the case where photographic images are made which *need* prescreening to read the image. Photomechanical methods are not necessarily "bad" methods. It is when they are used to reproduce an image from a water-colour, for example, that the resulting print enters the realms of reproduction. The halftone screen, the grain screen, three- or four-colour reproduction processes, black-and-white screenless photo reproduction processes, and so on are best checked with the techniques sections in chapter 3. A photographic image can be produced by the photomechanical method of any of the four printing processes—I have even heard of a photographic wood block. An eyeglass is a definite advantage here.

How to Identify a Photograph

A photograph is for many people easily recognisable—the image is held in the emulsion and we never see the paper. However, photographic techniques onto a fine paper can create difficulties in identification, especially in the case of a palladium or platinum print. In these cases, part of the printing paper has been coated with a light-sensitive solution, and the image exposed as if making a photograph. The result looks like a photograph but rests on a beautiful paper (such as Arches or Rives) with no halftone or other mechanical structure.

How to Identify Cast Paper

A paper work is composed of rugged pulp rather than paper (pulp in its usual refined, evenly pressed, and dried state). Usually a cast-paper or other paper work is in three-dimensional form; often a rough surface is exposed. (Refer also to "The Print as Cast Paper" in chapter 3.)

How to Identify Electronic Media in Printmaking

"Xerox" is a trade name, but *photocopy* is a general word describing any image in black and white or colour made by electrostatic means—either manipulated and copied, or as output from a laser, dot-matrix, ink-jet, or other computer printer. Images of any kind can be copied onto a variety of papers (even onto hand- and mould-made papers). A magnifying glass

is probably necessary to recognise any of these processes, unless you are able to rub the surface of the print—in which case some particles are likely to be dislodged. Many coloured "electronic" prints have a sheen over the printed surface that is indiscernible behind glass.

PRINT-SIGNING PRACTICES

A further way to recognise an original print is by the way it is signed. Conventions in the signing of prints, which the majority of publishers and artists today (and in the recent past) adhere to, are described in detail below. Of course, individual variations and occasional malpractice occur, but on the whole the rules remain constant and in use globally.

Historical Signing Practices

Signing in the plate

Monograms, symbols, devices (such as the drawing of a tool), letters, and even place-names engraved into copperplates were first used to identify an engraver. Before that, wood blocks and engravings did not usually bear any sign identifying the author. Identifying marks first appeared around the middle of the fifteenth century. Initials were often formed into a monogram, which was used to mark engravings and woodcuts. The monogram in a plate had to be included as a mirror image of itself; it can often be found in a characteristic position inside the picture. There is probably no more familiar device in the whole print field than the monogram that Albrecht Dürer always designed into his blocks and plates.

It is common practice for engravings made from paintings and drawings to bear two names on the plate. At the bottom left-hand side is the name of the painter or draftsman, followed by a Latin abbreviation certifying that this is his work—for example, *pinxit, delineavit,* or, more rarely, *invenit* or *composuit.* The name of the engraver also appears and is followed by *sculpsit, incisit* (which means "has engraved"), or *fecit* ("has made"). These engraved signatures appear the right way round on the print, and therefore must have been engraved in reverse on the plate.

Terms that a printmaker or craftsman might have used:

aquaforti—etched
caelavit—engraved
direxit, direx.—directed
f., fec., facie B.A.T., fecit—has made it
imp., impressit—has printed it (in modern prints, usually written in pencil after the signature)
inc., incisit—has engraved it
lith.—drawn or printed on stone
sculp., sc., sculpsit—has engraved it

Terms that a painter or draftsman might have used:

ex archetypis—from the original
comp., composuit—has designed it
del., delin., delineavit—has drawn it
fig., figuravit—has drawn it
inv., invenit—has designed it
pinx., pinxit—has painted it

Terms that a publisher might have used:

divulg., divulgavit—published
exc., excud., excudit—has published it
formis—at the press (used when the printer was also the publisher)
sumptibus—at the expense of (usually referring to a patron or publisher)

With the introduction of lithography in the late eighteenth century, it became the practice to sign the plate the right way round so that the signature appeared reversed on the impression (when printed on a direct press). The reason for this was the virtual impossibility of signing one's signature in reverse. A personal signature on a plate is a fairly good indication that the work has been made by the artist himself.

The custom and rituals of signing and limitation, which began in England with the Printsellers' Association in the nineteenth century, were adopted for original prints by James Abbott McNeill Whistler—who charged twice as much for a lithograph signed in pencil as for an unsigned proof. Although artists sometimes signed their prints before

Specific Qualities of Print Techniques

Below are illustrations of some of the main characteristics of the major techniques. These are reproduced by photo-litho in this book and, under magnification, a halftone screen will be apparent. The type of reproduction (for the purposes of this book) obviously interferes with the inherent nature of the technique illustrated.

1. Surface detail of a woodcut.

 Simplicity of shapes and forms, contrasts of black against white, bold cutting marks.

2. Surface detail of a wood engraving.

 Often very precise with a network of complicated lines, contrasts of black against white. Requires patience and much skill.

3. Surface detail of a linocut.

 Strong, bold, cut marks, little fine detail.

4. Surface detail of an etching.

 Loose flowing lines and areas with no particular grain or structure.

5. Surface detail of a hard-ground.

 Crisp, sharp, and worked lines, some of which have broken down in the acid.

6. Surface detail of a soft-ground.

 Looser, freely flowing lines, textured line and drawing.

7. Surface detail of an aquatint.

 Granular structure of tonal areas.

8. Surface detail of a drypoint.

 Sharp, unsoft quality to the line.

9. Surface detail of a lithograph.

 Use of the same tools as in drawing and painting. A hand-drawn quality to the image.

10. Surface detail of a lithograph.

 A handmade mark in line or tone, gentle or heavy.

11. Surface detail of a screenprint.

 Freely brushed lines of block-out stencil.

12. Surface detail of a screenprint.

 Sharp, cut shapes, hard edges to the image. Crisp lines. Strong colour.

13. Halftone system.

 Tonal structure of an image translated in pattern of dots.

this, at the request of the owner of the prints, it is only since the end of the last century that artists have slowly begun adding their handwritten signature to their prints.

The artist's signature

Today, the practice of signing is universal among professionals. However, a signature (engraved or handwritten) does not necessarily give authenticity or greater value to a print. The handwritten signature of an artist verifies that the artist is the author of the image and confirms that the finished work is how he wants it to be. The signature of the artist on the print is *not* a guarantee of originality, then, but one of authenticity and approval. (Note that the printing matrix usually remains the property of the artist; this is different from normal commercial or business practices, in which the printer is often the owner of the master image plate.)

Signing Original Prints Today

Signing is usually done in pencil, either underneath the image or at the bottom of the print (or occasionally on the back of the print). The whole body of prints made will be signed, including not only the edition but the proofs as well. Signing includes the edition number (or proof designation), the title, the artist's signature, and, possibly, the date, in that order from the left to the right of the print. Some artists and/or printers or publishers also affix a seal or chop mark to the work (see below).

With most printmaking techniques used today, there is seldom difference between the first and the last print pulled, so sequential numbering is not of great importance. With drypoints, mezzotints, aquatints, card prints, and collatypes, however, a slight deterioration may occur as the edition is pulled; in such cases, it is important for the sequential numbering to be accurate and to be identified as such to the buyer.

The fractions used in signing the edition are normally written in Arabic numerals—for example, $^{26}/_{75}$, in which 26 is termed the numerator and 75 the denominator. The denominator represents the total number of copies in the edition. In some cases the fractions are written in Arabic numerals for the pull (edition), but for all other prints and proofs the numerals are Roman (for example, $^{IV}/_{xx}$).

DESIGNATIONS USED IN SIGNING

There are numerous designations for proofs and all that editioning entails. An understanding of these terms, especially those used for proofs, is important, as stories of malpractice in signing are abundant. Proofs are printed at various stages during the making of a print; clarification and details of these stages are found below. The listings are of the ways in which various types of prints are signed and do not follow the making order, but are alphabetically arranged. The making is discussed in detail in chapter 2 but generally follows a pattern of:

1. state proofs, trial proofs, and so on

2. B.A.T.

3. edition and artist's proofs, presentation proof, printer's proof, and so on

4. cancellation proof

Signing of Types of Proofs (Outside of the Edition)

B.A.T. or Right to Print A B.A.T. is the final proof signifying agreement between artist and printer that the artist is satisfied with this print. There is only one copy of a B.A.T.; the artist signs it and this approved print becomes the edition standard. This proof becomes the property of the workshop director. In Europe, the term *B.A.T.* is used (from the French *bon à tirer*—"good to pull"). In the United States, the term *Right to Print* (*R.T.P.*) is more common.

Cancellation proof To assure that no further proofs can be pulled from the printing matrix after the edition has been printed, the printing elements (matrices) are canceled by either the artist or the print workshop director. The plate is defaced by either the use of a sharp or abrasive instrument to score the plate, the drilling of a hole, or the use of chemicals. A proof that verifies the cancellation of the master image plate is normally taken, especially from intaglio plates and wood blocks. This records the end of the edition and guarantees its limit. The artist signs

"cancellation proof," his name, and the date. If for technical reasons a cancellation print cannot be pulled, the circumstances are often fully explained in the documentation sheet. In French, *épreuve d'annulation*.

Counterproof If a sheet of paper is laid over the top of a wet print and pressure applied while the ink is still wet, it will produce an impression that is reversed and a little fainter. This impression can be used by the artist to make corrections and changes to the work; termed a counterproof, it is produced the same way round as the matrix—that is, back to front.

Experimental impression This is a unique impression pulled to study the effects of a specific printing process. It may be a one-off proof (comparable to a monoprint) or lead to editioning.

Ghost impression A term given to a proof pulled from the matrix after the first impression has been taken and before any additional inking of the printing matrix; a very light second impression.

Maculature When printing takes place, the matrix is usually reinked for each print. A print taken without reinking is called a maculature and is most often made in intaglio printing, when a second sheet of paper is run through the press to clean the surplus ink from the plate. It is similar to a ghost impression (above).

Progressive proofs These are a series of impressions made for a multicolour print, showing each colour separately and in combination with each of the other colours.

The term is also used to refer to prints that document the sequence of the final printing pattern of the numbered edition. More typical in the United States than Europe, these proofs often bear notations from the artist, the printer, or both. They are numbered (in the U.S.) in Arabic numerals and capital letters—for instance, 1A, 1B, 1C, 2A, 2B, 2C, and so on.

Rémarque This is a print showing a scribbled sketch or note made by the artist on the side of the plate outside of the main design (which may be unrelated to it). The practice was begun in the eighteenth century, mainly as a way of testing the strength of the etching acid on a plate before risking the biting of a main design. It was always burnished away

or ground off before the printing of the main edition.

Specimen Specimen proofs are used as samples for catalogue reproduction, publicity, and so on. They have no commercial value and are not signed except as "Specimen." (See also *Enhanced edition*, page 97.)

State edition If an artist alters the approved edition print image—thereby creating a new image—the resulting new image is, if printed in an edition, called a state print edition. When the artist decides to print a particular image in two or more states, then no cancellation print is made until the state editions have been completed.

State proofs These are proofs that show the evolution of the master image on the main plate. An artist who wants to check what he is doing, experiment, and change will print an impression from an unfinished plate. These are the stages or "states" of a plate; in some cases, the artist may draw on the actual prints to test what he wants to do next. They are usually few in number as they are working proofs. Occasionally, the variation in the states may be so great that separate editions are pulled from individual state proofs. In French *épreuve d'état*, the proofs are signed *State 1, 2, 3*, and so on. If these eventually come onto the market, they give insight into the artist's working methods. The study of states has also been useful in determining the sequence of printings. Many Old Master plates were never canceled, and were often printed long after the artist's death; as the plates were worn down, they were reworked by other hands to restore their usefulness. In these cases, a proper sequence of states can provide information as to whether a certain print was produced during the artist's lifetime.

Trial proofs These are proofs pulled during the collaboration—usually in a single colour, such as black—that document the image changes before the "Right to Print" (B.A.T.) is given. They do not exactly resemble the edition prints and are selected for their unique quality. Technical notations are often written on the print by the artist, the printer, or both. There is some confusion of the difference between a trial proof and a state. After the master plate is completed, proofs that verify the inking and wiping, colour of image, placing on page, pressure of printing, and so on are taken. They are a subordinate of the general term *state*. In French *épreuve d'éssai*, the proofs signed *Trial 1, 2, 3*, or marked in Roman numerals in lower case—*i/iii*, and so on.

Signing of (Prints and Proofs of) the Edition

In this list, each print is exactly the same as the edition; extra copies are always made, for a number of quite acceptable reasons, and although the designation *proof* is often given to them, they are part of the edition as a whole. Alphabetically listed:

Archive copy The impression, as the edition, created for and maintained by the publisher for exhibition purposes.

Artist's proofs It is a fairly recent custom to assign the artist a certain number of extra prints over and above the fixed size of the edition. Artist's proofs are the prints from the edition that the artist retains for his own use. The usual maximum is 10 percent of the edition number; the minimum, 5 percent. The proofs are signed *a/p* or *A/P.* If there is a large number of A/P's then these are also editioned in Roman numerals—*A/P I/XX*, and so on. In French *épreuve d'artiste.*

The edition (U.K.) or the pull (U.S.) In the early centuries of printmaking, plates were kept in the possession of the artist or publisher, who ran off impressions as needed until the plate wore out. The current significance of the edition arose in the late nineteenth century as a result of artificially limiting the supply of a print. Some believe it to have been a "ludicrous trick" that has now been adopted almost universally for marketing purposes; they say its success has been possible because of the "investor mentality of buyers" and the premium misguidedly placed on rarity.

Today, the practice of making editions has become more or less universal. The edition is the total number of prints—decided by the artist and/or publisher—that is required from the plate, black, or screen. These prints maintain a consistency of colour and a uniformity of impression. It should be noted that, with the techniques available today, each print in the edition is exactly the same. In only a very few techniques will the print quality vary from the first to the last print. Editions are not normally signed in sequential printing order. Edition numbers tend to be smaller today than in the past, and if the edition is limited in number, an artist or publisher may not print more. In French *tirage.*

When the edition has been printed and signed by the artist, the plate is canceled and a cancellation proof (see page 93) is taken as verification of the end of the edition in that form.

An edition is signed *1/25*, *2/25*, *3/25*, and so on. However, an edition does not have to be limited—in which case it is called a multiple (see page 99).

Enhanced edition/proofs These are proofs that include the manual addition of colour that was not part of the original plate(s)—for instance, watercolour, crayon, or pastel. This can be made either on only a few copies extra to the edition or throughout the entire edition. The coloured additions must be consistent and they must be completed before signing. Single copies can be signed as *Specimen*.

Hors commerce *or presentation proof* This is a proof outside of the edition number. It may be given to those who have helped in the making of proofs or, more likely, be used for sales purposes—that is, for travel and display. From the French for "not for sale," the proofs are signed *H/C*. If they are numerous, they also can be editioned using Roman numerals—for instance, *H/C V/XV*.

Insurance copies A publisher will, in many cases, print a small percentage of copies extra to the edition. These are for replacement if any part of the edition gets damaged—for instance, in transit or in the mail.

Legal deposits In some countries, proofs are required as legal deposits, as stipulated by law. These are signed *L/D* and, if numerous, can be editioned with Roman numerals.

Printer's proof This is a proof of the edition but not included in the edition number; it is given to the printer for his own use. Usually only one (or two) proof(s). Signed *P/P*. In French *épreuve d'imprimeur*.

Studio proof This is one copy of the print, outside of the edition, that is given to the studio—often for archival purposes. In French *épreuve d'atelier*, the proof is signed *S.P.*

Other Terms Used in Signing

Dates Museums and collectors often wish the artist to date (generally with the year only) his work, but not many follow this practice. The date is usually written either after the artist's signature or after the title.

It represents the date the print was signed, not the date the plate or the edition was made. Signed as *1996* or *'96*.

Dedication An artist will occasionally dedicate a copy of the print to someone such as a friend or publisher. This can be an A/P or part of the edition and is usually prefaced by *to*

Edition de tête A special deluxe edition. The term often refers to a portfolio or limited-edition book.

Imp. From the Latin *impressit*, meaning "has printed," this term is only occasionally used. It was popular in Britain during the 1970s when the debate about identifying master printers was at its height. When it is written directly after the artist's signature, it denotes that the artist has himself printed the work. If the artist or workshop requires that the printer also sign the work, then the printer signs his name followed by *Imp.* Current practice is for the printer or printing studio to chop mark the print. (See page 88 for other Latin terms.)

Inscription Often more relevant to the graphic art of the seventeenth and eighteenth centuries, *f., fecit, inv., sculpsit, inv.,* followed by the name, indicates the author of the engraving or the artist who made the original design—even if it was in a different medium, such as painting or drawing.

Other Marks on Prints

Collector's marks Collectors of the past or present have often placed a mark, stamp, or monogram on their prints, partly as a mark of ownership. These are usually made on the back of the print, but occasionally appear on the front. Such marks often add considerable associative interest to a print and, like studio marks, can provide a clue to the print's history and even authenticity—a print that once belonged to a famous collector is sometimes endowed with a cachet of quality. Most museum collections also have their own marks. Today, collector's and studio marks are often not handwritten marks on the back of the print, but rather blind embossings made with a small seal. They are called chop marks or chops in the United States, and blind stamps in Britain.

A document by F. Lugt (*Les Marques de Collections*, Amsterdam 1921, with a 1956 supplement) lists collector's marks. I myself have documented British printers' chop marks (*Print Quarterly*, 1992); U.S. printers' chops were recorded by Rebecca Schnelker in the *Tamarind Papers* (1989).

Studio and/or publisher's marks Looking at a print, it is often impossible to tell if a collaboration with a workshop or publisher has taken place unless the printer or publisher leaves his chop. The *chop mark* is defined as a small mark from a blind embossed seal that is impressed onto the front of the print by the printer or the print studio. On prints that bleed to the edges of the paper, the chop mark can appear within the design. It is often sited at the bottom left- or right-hand side margin of the print. Occasionally "wet stamping" occurs—a wooden or rubber stamp is used on the back (verso) of the print. If this latter method is used, it is usual to wet stamp with a light grey litho ink and not the ink from a rubber stamp pad. Not all editions printed in every studio are chop marked. For an edition to be thus marked, the acquiescence of the artist, the printer, the gallery, and the publisher is required.

Studio bookkeeping and other marks Occasionally, a well-organised artist or studio will utilise a rubber or wet stamp on the back of a print as an identification of the print in its bookkeeping system. Some artists have been known to use a rubber stamp to identify details of the print or printer.

The Signing of a Multiple or Uneditioned Print

A multiple is not a technique but rather an edition of an original print with no limitation placed on the number printed—that is, it is run (in any process) without editioning. This term really emerged into common usage during the 1960s to differentiate three-dimensional art ob-jects from traditional, editioned sculptures in which the artist often employed mass-production processes. Idealists producing these works maintained that they should be in unlimited editions and inexpensive, in order to democratise art. Many claim that there is a revival of interest in the multiple due to the difficulty of selling major works and the prevalence of anti-art strategies. Unlimited edition or multiple copies of

prints can be signed in various ways—in the printing (in the plate), in pencil by the artist without any edition number—or not signed at all.

The Signing of Portfolios, Suites, and Series of Prints

Series of prints, made for a variety of reasons—personal to the artist along a theme of his work, as a gift, as a commission, for a special event, for a special occasion, and so on—are often grouped and contained within a specially made portfolio. In such a portfolio there are often several special signing pages (listed here in alphabetical order):

Colophon On a separate page called the colophon (or inscription page), a list of the prints in the portfolio appears, along with other relevant bibliographic information such as the names of the printers and binders; relevant technical information as to the processes and printers; and the edition number and signature of the artist(s). Also added to this page may be a dedication. The colophon is usually found at the back of a suite of prints or on the reverse of the title page.

When such a collection or series is made with prints of one artist, it is usual for him to sign the colophon in full and then simply pencil his initials on the bottom right-hand corner of each print in the portfolio.

Leporello This is a print that has been designed to be folded after printing, either with one or with many—usually concertina-type—folds. The front page is usually the title page.

Title page The front page of a series, collection, or book of prints. It normally includes the title of the work, the artist's name, and the publisher's name.

REPRINTING OF AN EDITION

Restrike In this old practice—more common in the days of the print business when reprints of plates or popular images on plates were usual—plates are reproduced when need demands, rather like a publisher's backlist. Any reprint of a plate made later than the edition is called a restrike. The term is often often applied to printings made after

an artist's death. It is also applied to a plate that is reprinted after it leaves the artist's possession or control. If the plate has not been damaged, the quality may be excellent and equal to earlier editions. Usually, restrikes are neither signed nor numbered. They are more common from intaglio or relief blocks than from lithographs—where the stone or plate will have been erased for another use; or from screenprints—where the image is destroyed.

Preservation of blocks, plates, and so on There exist special facilities for canceled plates, often called depositories or centers for registration of printing matrices. In many instances these plate- or block-housing centres are part of professional conservation bodies—such as the center at The Bewick Studios in Northumberland, England. In such places, artists can lodge their canceled plates and blocks—which will be cared for and conserved by a specialist. These are rare and splendid facilities.

Posthumous Impressions

The printing of a plate after an artist's death occasionally occurs—if the plate has never been editioned and the trustees of the estate wish to publish it, for example, or if an artist dies in the middle of editioning. In these cases the print will today be titled and editioned but the trustees of the artist's estate will mark the print, in the form of a wet stamp or blind embossing.

Establishing the age of an old impression can present difficulties that are not easily overcome, even with the scientific aids available today. The problems presented by posthumous prints are no less thorny, unless the prints have been documented well.

Telephone bidding at the Contemporary Sale at Sotheby's, June 1995, in London.

Buying and Collecting Prints

Buy prints because you love them and not because you calculate they will earn money for you.

—Carl Zigrosser

THE COLLECTOR

Collecting is a passion. It is also a very old tradition—one that, in the case of prints, dates back well into the fifteenth century. There are extraordinary affordable works in the marketplace, and one hardly needs formal training or knowledge to pursue collecting. Saying that, however, I instantly rescind it: If you are collecting, it is fairly certain that—even if you began by simply being drawn to an image or by taking an interest in an artist—you have over time acquired knowledge and put it to sound use.

The art market is governed by supply and demand. There are probably more buyers today than ever before. Alongside this, auction houses and museums are more service oriented than ever before, providing information and opening the public's awareness to art through a host of seminars, lectures, exhibits, films, publications, symposiums, and more. Increased awareness has helped increase demand for works of art. Information—including extended coverage in the press and media—has been a key.

People who would never previously have thought of buying art in

any form have been drawn to buying prints, partly because of their price, and partly their accessibility. There is immense variety in the price range of original prints, from which you can choose whatever level suits your pocket. Original prints can be one of the cheapest art forms to collect, and as such can be collected by almost anyone. For a collector, the availability may be disconcerting; by keeping the price of prints low, however, the democratic as well as the original nature of the print as produced by the artist are being realized.

Every collector likes to imagine that the works he has assembled—whether bought cheaply or at great expense—are increasing in monetary value. Recognising value is a skill every collector can attempt to master.

Whatever the motivation for buying or collecting artists' prints is, it is my belief that every collector should have at least a basic knowledge of the subject of printmaking; it increases the enjoyment of prints and gives added confidence when making a decision to purchase. Given that the previous chapters go some way toward fulfilling this recommendation, this chapter concerns various aspects of buying and collecting prints.

First, we look at prices and the factors that influence them.

THE COST OF A PRINT

In practical terms, the price of a new print is in most cases based on a unit cost. The price grows from this basic cost as the print moves through various levels of trading. The final price, called the retail price, which the print sells at, takes into account the work of the dealers, agents, and other representatives.

When pricing a print, a gallery usually takes into account whether it is itself the publisher or is simply acting as a sales agent. Normally, it will establish a production cost and a selling (retail) cost. The production cost of an original print can be one of the largest factors in the unit cost. It includes materials; proofing, printing, and producing the edition (most of these costs go into the preparatory work with the artist; larger editions spread them); and the status of the artist, as well as the fee or commission that he commands. Also taken into account are the gallery's running costs and overhead (which include rent, electricity, sales staff, freight, publicity, auditing, and so on). Since editions may

sell slowly, capital is tied up over a long period.

Prices for works vary enormously, and some prints are expensive. Prints produced in collaboration with a master printer (often published by the specialist studios themselves) may involve highly creative work and protracted experimentation, which will obviously affect their prices.

How long it takes to sell an edition of prints by an established artist or maker is largely up to the managing dealer. It can take just a telephone call or almost any length of time. Factors such as the popularity of a specific image; whether it has been seen in the market before; and the existence of a current related or large retrospective exhibition can also influence the asking price of a print. However, if a print is popular and sells well, it is a known practice to raise the price as the edition runs out. Equally, some successful prints are withdrawn from the market for a number of years so that their rarity value increases.

The effect of the death of an artist on the price of his work usually follows a pattern. Initially, prices rise very quickly, because panic to buy and sell begins directly after the death of an artist; prices at auction often become astronomical. They probably stay so for a period of time, after which they start to drop and consolidate. They may take three years to settle. Many of the best galleries do not instantly raise their prices upon death of an artist—finding that the best images retain or increase their value, while lesser images fall in price.

BUYING PRINTS

Print-buying practices today include:

Direct buying A sale that occurs when the buyer is present, can view the work, and is able to ask for any further information he requires.

Indirect buying Many reputable companies today offer a wide range of prints for sale via illustrated catalogues. The practice is well established and suitable for those who cannot visit galleries themselves; the disadvantage is that you only see the work reproduced as a small glossy item in a brochure, and do not see the real article. Most mail-order businesses offer a direct-return refund if you are not totally satisfied with your purchase.

Information That Should Be Available to All Buyers

Certain basic information should be readily available to the buyer of an original print. However, the whole field of artists' prints is confused by loose definitions and vague terms; there are doubtful editions and occasional fakes, although these usually only appear in the highest price brackets. More common is the reproduction that is passed off as an original print. To some extent, only the buyer can judge if a print is what it is made out to be—but he can only make a reasoned appraisal if armed with all of the facts. However, there is no ultimate solution. Value will always fight with desirability.

Information about the following points should be sought by buyers:

Artist Signatures on prints do not always allow you to recognise the name of an artist. Not only should the artist be clear to you, but a short biography should also be available. You may wish to follow an artist's career, find other works of his in public collections, know something of his background and likely potential, and research books and articles on his work—all of which will help you to a fuller appreciation.

If you cannot make out an artist's signature, signature catalogues will often help identify its nature: full name, surname, or initials; position on a sheet; and so on.

Title Some works are untitled—there is no title to the work at all. Other works are titled merely for identification. In some works, however, the title is an important element. The title is usually (although not always) written on the work itself.

Edition The size of the edition is obviously of importance. If a very large edition (over 250) has been printed, rarity may not be be a factor in its future value. The number of proofs, artist's proofs, and *hors commerce* proofs should also be known.

Date The date is not always written on the print, but it is important to know when the print was executed in the career of the artist. Occasionally, a double date is seen—for example, 1958–1979. This usually indicates

that the artist started work on it at the first date but did not complete it until the second date.

Publisher A print is "published" once it reaches the marketplace. Many prints are published by artists themselves—often, little information is available in these cases. If a stamp or chop establishes the publisher, you will usually find that the published work is documented fully. In many cases, the name of the publisher is a guarantee of quality and authenticity.

Printer When an artist has collaborated with a printer, it is reasonable to be told so. The particular collaborative venture usually adds to the print's value.

Technique It is not always easy to guess the medium or processes used in a print, especially if it is framed. No one medium is better or worse than another—only the way in which the media are used. A publisher should give a description of the medium, number of colours, and details of special procedures and effects.

Paper The paper on which the image is printed can be of great significance; the quality of the paper will seriously affect the permanence of the work. (See page 126.) It has become common practice for only one type of paper to be utilised in an edition, but European publishers in particular often print a regular edition on standard paper and a second, smaller edition on a rare (or interesting) paper. This may affect the rarity value of the print. Details such as the name of the paper, weight, watermarks, image size, paper size, margins, and published size should all be given on request.

Cataloguing If information about the print is contained in a catalogue issued by the publisher (which is usual in cases of well-known artists), it does not need to be repeated on a receipt. It is best for you to keep both for future reference, however, as they may become important factors in resale or exchange. Some publishers issue a certificate of authenticity with each print, which usually contains the essential information; there is no legal requirement to furnish this, but many publishers do so to allay

public worries about the authenticity of the prints that they publish.

General advice

General advice to would-be buyers is more often than not simple common sense.

1. It is sometimes the case that, given ambiguous wording, you are unclear as to the true nature of what is being offered for sale—for instance, it may be impossible to know whether the print is an artist's original or a reproduction (signed or unsigned). In these cases, ask for more information and for a full catalogue of all of the company's publications, to enable you to build up a better picture of it.

2. Offers that promise they are an "investment for the future" are probably best avoided, as such a claim cannot be verified.

3. If you wish to buy at auction from a catalogue, you will likely be able to discuss the work with a representative, who will give you the information you require. Still, it is always wisest to look at the work yourself beforehand.

4. Prints by deceased artists, particularly if they are well known and the prices seem very low, may be restrikes (see page 100).

5. In general, it is wiser to only buy from galleries and companies that have a good reputation and that have been dealing long enough to prove their genuine concern for artists and collectors alike. Many established galleries and publishers run flourishing print clubs that offer their regular clients a number of prints each year for a flat-rate, annual subscription fee.

A Receipt of Sale

When you buy a work, in addition to asking for a print documentation sheet, it is always wise to enter into a written agreement; this circumvents the obvious dangers of a verbal agreement, and also helps to understand the agreement fully. Discussion should always precede a contract of sale so that any details that might cause irritation can be

ironed out. In order for a contract to be legally binding, there must be an offer from one party and an acceptance of that offer by another; the subject matter must be definite. It need not necessarily be formal, but a contract or a bill of sale clarifies for both parties the arrangement being entered into, and gives certainty as to the terms agreed upon.

Essential elements of a receipt or contract of sale are:

- The certainty of the identity of the parties (i.e., buyer and seller).
- The identity of the subject matter of the contract.
- The date.
- The price.

Other items that may be listed on a contract of sale include discounts, details of any taxes (such as VAT), the terms of payment, and who owns the copyright (and whether any licenses have been given). A purchaser may agree to inform the artist or publisher if the work becomes damaged, and may allow the artist or publisher the right of first refusal to repair the work; he may agree to lend the work for exhibition purposes. The artist may wish to accept his right to be identified as the author of the work.

COPYRIGHT

Copyright (or privileges) for a limited number of years have been given to books and prints by many governments since the fifteenth century. Artists and publishers have sometimes signaled such protection to potential pirates by adding copyright lines to their blocks and plates.

Today, copyright is essentially the right of a creator not to have his creative work copied with impunity without receiving some sort of compensation (usually financial).

Who owns copyright? The general rule in Europe and the United States is that the creator of an artistic work is the first owner of copyright in the work. There are, however, exceptions; these occur mainly when a work is created in the course of employment or commission.

How long does copyright protection last? The term of copyright

varies among different countries. In Britain, the term is usually the life of the artist plus fifty years from the end of the year in which he died. Recent legislation aims to increase the length of copyright to seventy-five years.

Copyright or the right to copy or reproduce art is governed in the U.S. by the United States Copyright Act. In October 1988, the U.S. passed legislation to make itself a party to the Berne International Convention for the Protection of Literary and Artistic Works. This agreement states that it is not mandatory for the artist to place a copyright notice on his/her work to obtain copyright protection. This, however, only applies to works published after 1988. Works published earlier must still comply with the United States Copyright Act.

Rights of the copyright owner A copyright owner has the exclusive right to copy the artistic work in which he owns copyright. Copying the work means reproducing it in any medium; it requires the specific written permission of the copyright owner. Authorisation for the copying can be given as a nonexclusive license, an exclusive license, an assignment, or a bequest.

The right to copy a work is regarded as distinct from the right to tangible possession of the work. Thus it is possible, and usual, for an artist to sell a print but retain the copyright. Indeed, under the copyright acts, unless the copyright is specifically granted to the purchaser of the work, it remains the property of the artist. An infringement of copyright occurs when a person reproduces an artistic work or deals with it without the authorisation of the copyright owner. For instance, the copyright would be infringed if the work were reproduced in the form of a postcard without permission from the copyright owner.

INVESTMENT IN ART

Prints can, of course, be bought as investments or speculation. The real pleasure in collecting contemporary prints, however, must lie in the collector's involvement with this particular art form in the course of decorating a home or workplace, and feeling reasonably sure that its value will at least be maintained.

For serious investors in art, a guiding rule must be to buy what you like at prices you can afford—and maybe afford to lose. It is certain that

pleasure should be your main aim, for if prices fall, your sole reward could well prove to be the "aesthetic dividend." It is wise to be aware that the potential of any asset appreciating is speculative. However, art can be a way of boosting tax-free investment returns. In terms of investment, art obviously offers little prospect for income, as direct investment in an original print yields no dividends as such. The costs of holding and caring for the work purchased can also be quite high—unlike share certificates, which can be easily and cheaply filed away, prints need maintenance, care, insurance, and even occasional restoration. They can, however, if chosen well and at the right time, prove a suitable alternative to conventional investment and sometimes provide a good hedge against inflation.

Potential investors should take into account considerations such as the outlook for inflation and for interest rates. The amount that someone buying prints has to spend is often related to an annual income. One financial journal in Britain suggests that a prudent strategy would be to consider committing no more than 10 percent of disposable income to art and—for safety—to view it as a mid- to long-term investment with a holding period of at least five years.

It is wise also never to underestimate the changing cycles of taste in the art world. As often happens, "Today's taste is tomorrow's white elephant." A collector may, of course, discover an artist at the beginning of his career, or find an important print in an unlikely, out-of-the-way gallery. However, all advice points to previous guidelines—plus knowledge and scholarship—if one is buying in a particular or specialised area of work.

According to a recently published art and antiques survey by Phillips (Auction House), prints did not feature among the top auction performers of 1994; those distinctions fell to sixteenth- and seventeenth-century portraits, Victorian and Edwardian jewelry, and early English pottery. Advice from Sotheby's indicates that it is essential to buy works of real quality and pieces that are in good condition; these remain the two most important considerations when investing in art.

If we look at the major factors that influence the price of any work, they fall into the distinctive categories of:

- authenticity
- quality
- condition

- rarity
- provenance (ownership track record)
- historical importance
- freshness to the market
- fashion and the art market

Quality and Condition

When assessing a print's quality, one must consider whether it has been technically well executed. This may require some experience, knowledge, or even expert advice. The following points are worth considering carefully:

1. The condition of the printing surface (plate, block, or screen) at the time it was printed.
2. The skill with which the plate was inked.
3. The care and skill with which it was printed.
4. The choice of paper (In modern prints, the sheets are usually of the same fine-quality paper).
5. The care taken to preserve it.

If the paper of a print is dirtied, torn, or damaged in any way, or the printing not of a professional standard, the impression will always remain inferior.

There can be good or bad impressions of a print. The problem is more pertinent to Old Master prints than contemporary productions, since in most studios today professional standards are encouraged; publishers place a high value on these standards and will only present the artist with a perfect edition for signing. The majority of artists who print for themselves today also are aware of the need to maintain high edition production standards.

Information about the edition, the number of states, and the fate of the matrix is not always available. However, exhibition catalogues or

catalogues raisonnés (see page 118) may well hold some of the answers; the publisher, printer, or even artist may also be able to answer any queries. A print documentation sheet is available and is the best source for information. (See also below.)

I would advise a collector to purchase from a reputable dealer or publisher, and to consult *catalogues raisonnés* wherever possible and/or necessary. Catalogues for important exhibitions and auction sales are prepared by specialists who will, if necessary, have called upon the advice of experts.

A final point, however, is that the concept of quality can be difficult and specious to define. The aesthetic quality of judging printed impressions will remain subjective.

Rarity

What is rarity? Well, the availability of a print depends basically on two factors: its rarity (that is, the total number of surviving impressions) and the demand for it—and demand can increase as well as reduce the supply.

Rarity often is artificially created and it is worth stating the obvious here—that rarity has nothing to do with the quality of a print, although it may increase interest in it.

The word *rare* can mean that there remain only a few impressions, which are only available in public collections. Some prints that were initially issued in large numbers have gradually disappeared over the centuries. Also, a print of which there is only one impression (a unique work or monoprint) may well be judged differently from one of which there are many impressions.

Rarity is a specious question. An artist can only make a name for himself over a period of many years, however good he may be. Some artists make names for themselves during their lifetimes, others do not; some artists become popular through notoriety, others remain obscure all their lives; some artists' careers are helped by a publisher, others prefer to produce work alone; a critic's appraisal can give encouragement and help to a career or, conversely, deny it. All of these factors can exert some influence on the rarity of a print.

LOOKING AT OTHER PRINT COLLECTIONS

Many museums have fine collections of historic and contemporary prints available for study. They usually exhibit only part of their collection, taking a theme or focusing on one artist, while the rest remains stored in boxes in the "print room," which the public can sometimes visit by appointment. In the past, members of the public have been deterred from using these collections, but most museums now are more approachable. The print rooms are not, however, designed for the casual visitor who has only a vague idea of what he wants to see. Check the collection catalogue first to identify exactly what you want to see. The staff will explain the organisation of the catalogue and how to put in a request. In museums, prints are generally kept in solander boxes and albums in storerooms; they will probably have to be located and brought to your seat in the print room, where you can study them in detail. Museums with an applied-art bias may have displays on general or specialised printing methods and arrange demonstrations of printmaking. Many museums set aside particular times when they will identify works that the public bring to show them; they usually do not give valuations, however.

ART MAGAZINES

The general press rarely reports developments in printmaking and art critics still neglect it as a subject of interest. Some specialised art magazines cover print exhibitions regularly: *Art News* in America and *Art Review* in Britain are most useful in this respect. *The Print Collector's Newsletter*, published bimonthly in New York, has useful articles, reviews, and information on prices. *Artist's Proof*, now called *Print Review*, has been published for many years by the Pratt Graphic Institute in New York; back issues are useful and can be found at specialist libraries. *Nouvelles de l'Éstampe*, published six times a year by the Comité National de la Gravure Française in Paris, covers new acquisitions to the Bibliothèque Nationale and general print activity internationally. *Printmaking Today* is the first British magazine to devote its entire contents to contemporary printmaking; *Print Quarterly* is the only British journal devoted to scholarly issues of printmaking. The catalogues issued by the international print biennials,

such as those of Ljubljana, Kraków, Norway, and Tokyo, are mostly well illustrated and give a good view of international trends.

THE ART MARKET

For a buyer, it is always essential to be as clear as possible about what you are getting and, if possible, to be aware of the advantages and disadvantages in terms of financial outlay.

The art market supposedly follows the economic cycle (and in Britain, incidentally, the house market also). In the late 1980s, the art market boom made investment in art (and also antiques) seem like a sure way to a financial killing. Increased demand was spurred by the supply of outstanding works coming onto the market. Fortunes were certainly made—but were also lost in the subsequent and deep recession of the early 1990s. While top-quality items may have held their price, falls of 50 percent and more for mediocre and overexposed items were not uncommon. After four very depressed years, 1995 saw only a few signs of revival. Unless under pressure from death, divorce, or debt, potential sellers were hanging on for higher prices.

A Note on "Unpurchasable" Art

"Temporary art" is not only only a growing trend but probably also a reliable monitor of the recession. Because the bottom dropped out of the market in terms of buying art at the end of the 1980s, the idea of making something that would last forever seemed less crucial to many artists, who went back to making things far more fragile and transitory.

Temporary art began to flourish in the 1960s when Dieter Roth exhibited suitcases full of cream cheese; since then artists have used chocolate, urine, salt, roses, and so on in their work.

Damien Hirst is one of the more widely known protagonists in this field. His *A Thousand Years* consisted of twin glass cabinets, one containing maggots, the other a putrefying cow's head and a neon insecutor (the work had to be changed every seventy-two hours). Public spaces such as gardens, sidewalks, and shops provide different types of exhibition spaces. Artists have also used bus shelters, billboards, and bus and

taxi signs to confront us with their ideas and opinions in multiple form. Land artists work out in the fields treating them as galleries; their work is designed to be part of nature rather than taking nature out of its context.

However, while some artists, such as Andy Goldsworthy and Richard Long, have produced photographs of their work (and, incidentally, prints and books)—permanent images to sell to the public—many artists have refused to do so, wanting to retain a more dynamic relationship between the work and the viewer. Art that does not last, that deteriorates, or that has a short life span has become popular and even desirable to collectors—even if only in the form of a certificate. While the average print lover will want something to fill a space on a wall, collectors of temporary art are happy to trade in paper certificates. These collectors believe they are collaborating with the artist in the role of patron rather than purchaser and do not feel the need to possess something. Paying for the work is really only a way of participating in the event. Sometimes a certificate will allow a collector to re-create something over and over again, or to make an installation himself. With this kind of work there is no original in the first place—only one appearance of a piece that deteriorated; only a performance. What began by today's artists as a reaction to over-inflated prices is now, in Britain, beginning to fetch high prices of its own. The work obviously cannot be considered an original print, although the techniques of printmaking are often involved as part of the work in its entirety. How one views this work is completely personal, but my guess is that certificates and documents of these events will eventually come into the salerooms, perhaps in an original print sale.

EXPERT HELP

For those wanting outside help and advice when buying, it is often wise to establish a rapport with a good dealer or auction house expert. However, a proverbial piece of advice for would-be collectors (often reiterated in financial journals) is that buying in an auction room may be cheaper, but buying from a reputable dealer is safer.

"Art market consultants" have proliferated in the United States, but in Britain this particular field of expert advice has never really taken off. An example of the top end of the market in America is Citibank, one

of the few institutions to offer its clients (and those with reciprocal banking arrangements) a tailor-made art advisory service. However, this is not cheap; its target market is active collectors with a million dollars or more to spend.

BUILDING A COLLECTION

The advantages of collecting are multilayered. One is that involvement in the creation of a fine single-owner collection can itself reap rewards. More than ever before, such collections are highly prized. They add the quality of freshness (works that have not been exposed to the market)—itself a seemingly vital prerequisite for future resale—to cohesion of content and fine provenance.

WHERE TO BUY PRINTS

Today, prints are available from a multitude of types of selling spaces—ranging from the artist's own house or studio to a private gallery, public space, museum, funded gallery, artist-run cooperative, print workshop, publisher's office, bank, restaurant, shop, hired space, open exhibition (such as biennial or triennial), mail order, large auction house, small saleroom, market stall, and even a car-trunk sale.

Often, seeing a work in its context contributes greatly to one's perception and appreciation of it. The advantage of galleries is that most provide a controlled environment in which an artwork can be favourably presented. Works can be bought after consideration; it is not usually necessary to decide on the spot.

Exhibitions provide one of the best opportunities for the public to view contemporary works, and they often provide artists with a range of opportunities as well—from exhibiting their regular work to experimenting with new ideas in the public arena. A number of large and/or capital cities have held major international exhibitions of contemporary prints since the mid-1940s. Major exhibitions in the form of print biennials and triennials can capture a global state of the art—unable to be viewed as such at any other place or time.

AUTHENTICATING PRINTS

The word *authentic* really means, in the context of original prints, that there is no doubt as to a print's artist or origins. It also refers to the print's condition and appearance—has it been restored, changed, or altered in any way?

Whatever the age of the print, historical research or reference can help greatly in authentication if the original details (see below) are not available. To identify a work—or indeed any details that you are not sure of—first do some research of your own. A biography, autobiography, or monograph of a famous artist will be of use to collectors concentrating on particular artists or movements. A general study of the period in question is usually easy to locate from a bookshop or local library; if not, consult a specialised library in a museum or university. Another useful source of information is the catalogues of print exhibitions or the catalogues issued by print publishers; however, these are rarely collected consistently by libraries, and it is more likely that *catalogues raisonnés* are available.

A "catalogue raisonné"

Catalogues raisonnés are formally published catalogues—usually only of major artists—that give a complete list of an artist's work. (The first known *catalogue raisonné* is the one by Edme-François Gersaint [1696–1750], one of the most important art dealers of his time and the author of the first critical inventory of Rembrandt's etchings, published in 1751 in Paris.) *Catalogues raisonnés* may also list items in a specialist collection, or a publisher's total output. They are of particular importance to collectors (and print dealers) because they give the fullest known details of every work; they can thus be used to identify works and establish their authenticity. *Catalogues raisonnés* are today often richly illustrated, and contain selective lists of the artist's prints along with comments of varying length, providing the reader with an introduction to each one. The catalogue is usually arranged in the following manner:

- the edition number, the title of the print, and the exact or approximate date that it was executed.

- the techniques used in the work.

- the measurements of the entire impression (height times width), along with the size of the image itself and of the margins.

- existing proofs and states, and their numbering.

A further step in your quest for identification and authenticity would be to consult an expert from either an auction house or a museum. Most major museums have conservation departments or will recommend a specialist—an art historian, a scientist, or a conservator. Each has his own part to play in authenticating the work. Elaborate authentication processes do exist, including scientific analysis of the materials and techniques, dating by materials as well as manufacture, recognition of style and appearance, and so on. It is not necessary to list here all of the techniques used for identifying the details of a work, but collectors should realise that they are available. They may well cost a lot of money, however, so proceed stage by stage quite slowly.

SELLING PRINTS

When you are selling a print, the two most important requirements are first, that it be in good condition and second, that the seller has the original invoice or receipt plus all of its details—so that there can be no doubt as to its validity.

When approaching a particular dealer or gallery for selling purposes, it is always wise to choose one who shows the same sort of prints, in terms of both price range and style. One can save time by writing to the dealer with a full description of the print. Remember that most dealers will want to buy at a price that allows them a resale profit margin.

One way to sell prints is to advertise them in the specialist press, art journals, or the best national daily, Sunday, or weekly papers. As much information as possible must be given: artist, title, price, medium, date, edition size, number of colours, and overall paper size. The smaller dealers as well as other collectors tend to respond to such advertisements and advertising will reach a wider public than by direct selling to the established dealers.

BUYING AND SELLING AT AUCTION

Selling by auction—where the object goes to the highest bidder—is an institution that dates back to the earliest times. The London firms of Sotheby's, founded in 1744, and Christie's, founded in 1766, whose activities are reported in newspapers and magazines, have for some years now controlled about 80 percent of the entire world auction market. (In Britain, Phillips and Bonhams supply the middle market.) The explanation for this is, in part, the favourable environment granted to English firms, such as their almost absolute freedom to import and export works of art and currency; but it is also due to the efficient management of the English firms, which are therefore in a position to offer more advantageous terms to clients. New York is the home of Parke-Bernet, which since 1963 has been affiliated with Sotheby's.

Both buying and selling at auction can be time consuming and subject to hazards; it is wise to become informed before attempting either. The value of a given print depends to a large extent on its condition, and auction houses usually have a print expert available with whom one can discuss these sorts of details. The auction house will value the work, and advise on the best time for it to be sold, and advise on the setting of the reserve (a lower price limit below which the print cannot be sold). The cost of these services is usually a premium on the selling price. Note that some auction houses take a premium from both seller and buyer.

Prints can be sold at auction, but the average collector is not as well placed for this as the art dealer—who may be an expert in timing and placing works in auctions. Larger auction houses have one or two special original print sales each year, which are to be preferred if the print is of great interest. Smaller auction houses sell prints in general sales. These are, on the whole, for average works, which rarely fetch good prices.

Practically all sale catalogues issued by auction salerooms are written in English—occasionally French and German as well. The experts who compile them often use a special terminology to describe the prints, with which a collector should be familiar (although experts are always at hand to answer queries). In the majority of catalogues, prints are described in detail. As an example, here is the description of two prints offered in a December 1994 Sotheby's auction of Old Master, nineteenth- and twentieth-century, and contemporary prints:

Lucas Cranach

THE TEMPTATION OF ST. ANTHONY

Woodcut, a good but damaged impression of the second (final) state, on paper with a Crowned Armorial watermark, trimmed outside the borderline above and at sides, lacking approximately 20mm below, a repaired horizontal tear extending from right to the centre of the image, other short repaired tears at edges of sheet, two horizontal central creases, small nicks and tears at edges, other minor defects.

(Size and price estimate)

James Rosenquist

SISTER SHRIEKS

Monotype, screenprint and collage printed in colours, 1987, signed, titled and dated in pencil, inscribed presentation proof 2/2, on wove paper, with blind stamp of the publisher, Graphicstudio, University of South Florida, Tampa, the full sheet printed to the edges, in apparently fresh, excellent condition (unexamined out of frame).

(Size and price estimate)

DONATING COLLECTIONS

The pleasure of accumulating a collection may well be matched at some stage by the dilemma of how to dispose of it. Various options exist, besides that of inheritance, and regretfully in each country federal tax

laws respecting charitable donations have a significant impact on the resolution of a collector's choices. If the aim is realising financial gain from a collection, seek advice on selling—not donating—it. Much depends on the financial circumstances, age, family, and tax position. Take advice.

Caring for Prints

Quite unconsciously, you may assume that once you have bought a print there is nothing else to do—the work will last forever. Unfortunately, a work begins to deteriorate from the moment it is made. I have learned that owning a piece of art has its responsibilities and necessitates investing care in a variety of ways. Because of the age we live in—where anything that develops signs of wear is replaced—taking on the the responsibility of caring for a collection is not always easy. However, by simply reading this book, your collection already has a better chance than many.

What is important to realise is that as private collectors, the works we have bought are hung in our homes (or work spaces)—not in a national collection. In our homes, we probably have a range of climates, variable lighting, and inadequate storage space; and, perhaps most important of all, we are untrained ourselves. We are simply individuals who have bought works of art. At one and the same time we are the greatest advantage and the greatest danger to our collection. We make all the decisions about the works—how to frame them, hang them, move them, clean them; we heat the rooms they hang in; we smoke; we vary the temperature and the lighting; and when we notice damage occurring to prints, we are the people responsible for choosing whether to reframe them, mend them ourselves, or choose a conservator to mend them.

This chapter, then, is about caring for the works of art that you own. I have learned that once you have acquired a wonderful print, its life span and quality can be greatly enhanced if you become informed, learn a few sound, basic premises, exercise simple controls, and use safe materials.

(Technical terms such as *conservation, restoration, acid-free, pH, mount,* and *mat* are used here; these are professional terms, and explained in a special glossary on page 149.)

GENERAL ADVICE

Many years ago, I listened to a lecture at one of the International Art Fairs in London; as I recall, the speaker listed simply what a collector should do with his art purchases:

1. Make a list of what is in your collection.

2. Describe the pieces accurately and in as much detail as possible.

3. Photograph them (when newly acquired, if possible).

4. Store them well.

5. Frame them well.

6. Have them valued regularly.

7. Insure them.

8. Keep a file on them, to include your original sales receipts and any information about them—press cuttings, catalogue entries, and so on.

This list remains pertinent. The sections below concentrate on aspects of it.

Valuing Prints

How do collectors cope with the problem of knowing what their possessions are really worth? Those of us who have not looked at our print

collection for years may find that suddenly, because of their rise in value, we have to ask ourselves the question: Can we afford to keep these works of art? Can we afford to look after our prints—let alone protect them and insure them?

The first wise step is to get each work appraised or valued. Usually, this appraisal is received in the form of a document that provides a collector with a professional description of each print he owns, and also tells him what it is worth. The major auction houses obviously have appraisal experts, as do art dealers' associations. The purpose of the appraisal must be made clear to the appraiser as, for example, an appraisal for estate-tax purposes may be different than an appraisal for insurance purposes.

Insuring Your Collection

Intense interest in art has produced, in the last couple of decades, a whole new group of specialists in specific branches of art—and this includes insurance brokers. Statistics show that insurance companies pay out more for damage claims than they do for theft claims. Theft is obviously one of the concerns of a collector, but defacement, breakage, and damage by water or by fire must also be of concern. In these cases it is essential that you obtain the advice of a specialist; he will undertake to explain in detail all of your necessary considerations. For example, damage to an art work involves two considerations—first, the cost of restoring the article to its original condition to the best of a conservator's ability; second, the loss of value the work may have suffered as a result of the damage.

Because of the various tax laws in each country, insurance has become more significant than ever in asset protection. It is important to get this right. Traditionally, an item is appraised; the appraisal is handed to the insurer, and then becomes the basis for the insurance policy. Be sure to discuss with your insurer a special policy covering art—usually a "valued" policy, which is different from one covering, for instance, jewelry or cars.

It is usual for an appraisal of a work's value to be made and then updated every one or two years. In volatile art-market times, however, it may be necessary to update your appraisal once or even twice a year.

Insurance policies often require confirmation that the collection is being looked after and also kept safe with sufficient security. The basis of the payment of claims will depend on your negotiations with the insurers and the range of your collection. Detailed understanding—especially of a policy's small print or specific language—is necessary; you may wish to seek advice. To find a respected art insurer, talk to your local museum, another collector, a known art dealer, or a gallery owner.

Causes of Damage and Deterioration to Prints; Preservation

A wide variety of materials has been utilised throughout the history of printing to make art; some of them were not necessarily chosen with long life in mind. The continued survival of prints and collections depends on the willingness of collectors (and scientists and conservators) to support the prevention of deterioration by preservation.

Paper

Paper is of enormous consequence when contemplating how best to care for your prints. It is vulnerable, and its life span is determined by two major factors—the way it was made and the way it is subsequently cared for.

The points below sum up briefly the chief causes of damage to papers:

Inherent Faults Inherent faults in a sheet of paper may occur at the time of its making—insects caught in the pulp, hairs, copper or iron particles, drips from the papermaker's hands, and so on can all start a chain of reactions.

Chemicals The introduction of various chemicals into the papermaking process, as well as chemical bleaching and even the use of low-quality fibres, can cause the paper to be of poor quality from the beginning. For instance, if the paper was made before stringent controls were enforced, it could contain unrefined wood pulp, chlorine bleaches, or unstable sizing elements, all of which cause darkening and

embrittlement of paper. Almost everyone is familiar with the rapid yellowing of newspapers left in sunlight, which is caused by internally generated reactions catalysed by external forces. Deacidification (also called acid neutralisation or buffering) is recommended for these kinds of rapidly deteriorating papers. However, before resorting to deacidification techniques, take advice, because the process itself may change other characteristics of the work. (The chemicals may penetrate unevenly; the work's paper color or pigments may change.)

Artists' methods Methods used by the artist may be the unintentional cause of many conservation problems. Pigments may not be fast, or may be incompatible with the paper beneath. It is important for collectors to realise that the ongoing problems of some artists' materials can be lessened significantly by proper climatic conditions, framing, storage, and exhibition.

External sources Deterioration arising from external sources takes a far greater toll on prints and drawings than that arising from internally generated effects, and is plainly easier for collectors to control. You may not be aware, however, that the same factors that cause deterioration can also—when correctly monitored—significantly extend the life expectancy of the work of art (even one with inherent problems due to the materials from which it was created).

People Very often it is you and I who cause the most damage. Irresponsible habits have led to the demise of many valued works of art. Damage by dirty hands, rough handling, and patching, mending, or restoring by amateurs can often do irreparable harm.

Environment That aside, a contemporary living environment is perhaps one of the most dangerous places for your prints to be kept in. Conservation practices have changed their orientation over the last twenty years to emphasise prevention of deterioration through control of the environment. The temperature and humidity of your house will affect your prints. It would be convenient if we all lived in moderate temperatures all year long, and if the humidity never rose above 40 percent. Since we do not, however, the vagaries of the weather can be minimised by modifying the internal climate of our homes via air-conditioning and dehu-

midifiers. It is wise, for your prints' sake, to avoid excessive or fluctuating heat. If the air is too dry, the paper will become brittle; if the air is damp, the humidity may lead to such conditions as foxing (caused by a chemical reaction between the iron salts present in most papers), mould growth (moulds feed on the iron salts in the paper), and mildew. Mould spores are always present in the atmosphere, and damp conditions offer them opportunities for growth. If possible, keep the relative humidity at 50 percent or below, and the temperature fairly cool.

Dust, dirt, and pollution Dust abounds in our homes—from open fires, central heating, pollution, and so on—and it is possibly even more harmful to prints than damp. If it accumulates on a print, dust can penetrate the pores and seriously damage it—the particles can get into the fibres of the paper, producing smudges and discolouration. Chemical and abrasive actions by different substances in the dust can also stain or abrade the paper fibres. Dust and pollution are urban problems; sulfur dioxide, nitrogen oxide, and nitrogen dioxide are particular threats in highly populated areas. These gases mix with water or moisture in the air and are converted to acids—which are particularly harmful to exposed surfaces.

Light Sun and man-made light are something we take for granted. However, light fades and discolours most works on paper. It is advisable to never display a print in direct sunlight, even when the work is framed and protected by glass; few papers, colours, or inks are completely immune to strong sunlight. Strong electric light can also harm printed works. Ultraviolet light is the most harmful wavelength; it fades colour and causes some papers to darken, others to yellow, and still others to bleach out to a paler shade. If fluorescent light is necessary, an ultraviolet filtering device should be used.

HANDLING PRINTS

Along with making sure that the work has been printed onto quality paper whose long life span can be anticipated (see page 108), proper care of the finished work will benefit the artist and collector alike. Below are a num-

ber of straightforward guidelines for looking after paper and prints:

1. Paper and prints can be bruised, creased, wrinkled, or dirtied almost too easily. They should always be handled gently; carry them using the thumb and forefinger of each hand to grasp the parallel short edges or opposite corners. The work should also be cradled when lifted so that the paper flows in an unbroken wave.

2. Prints should always be be handled with clean hands to protect the margins and edges from grease or dirt. Faulty handling can cause a kink in the paper or the print; the creases produced are often irreparable.

3. Prints should be carried and stored flat, if possible. Loose works on paper should never be rolled up for long-term storage.

4. Works on paper should ideally come into contact only with a rag mounting board (with neutral pH), with other good-quality paper, or with white, acid-free tissue or glassine. Low-quality paper and cardboard or chipboard folders, mounts, or frames, for example, will stain paper after only a short period of contact.

CARE WHEN BUYING PRINTS

Prudent collectors always examine their purchases carefully. Inspection for creases, tears, dirt, greasy finger marks, cracks in ink layers, retouching, mending or cleaning damage may be necessary. By looking at the back of the print, you can usually perceive any serious damage that has occurred to the paper. Looking with a magnifying glass from the back (if possible, over a light box) will bring previous mends and repairs to light.

Many prints have been slightly damaged by the inadequate care of the sellers themselves. The very best galleries and dealers will "float mount" your purchase—that is, wrap it in acid-free tissue and place it between two stiff boards, which are then taped together. This means that whichever way the print is carried, it is protected from damage by dropping or creasing. It is always wise to take along your own portfolio to

carry the work if you think that float mounting might not be available.

TRANSPORT OF PRINTS

Prints on paper are probably the easiest works of art to move from one place to another. Carrying by hand is usually done in a portfolio (see page 132). Transporting a work is a temporary state of affairs; whatever state the print is in (either rolled or with others in a grouping) will not last.

Rolling

Prints are most often packed in tubes to send by mail. It is very important to use a tube of sufficient strength; the wall of the tube should not be less than 0.5cm thick. Equally important is that the tube should be of sufficient diameter so that the print is not too tightly rolled—no less than a 12cm diameter is preferable. To protect the ends of the print, the tube should be long enough to extend at least 8cm beyond the rolled print. The print should be placed face up on a sheet of acid-free tissue paper, and another piece of tissue placed on top. It should then be rolled up so that the roll is just smaller than the internal diameter of the tube. A third piece of tissue is then rolled round the print to prevent it from unrolling and rubbing against the sides of the tube. Pads of crumpled tissue at each end of the tube will keep the print from moving about inside it. Some tubes have fixed ends or caps; if not, a round piece of cardboard should be cut and taped over the ends to secure the package. Most prints are rolled with the image facing in, but screenprints with heavy layers of ink should be rolled with the image facing out, like an oil painting. Prints should be kept rolled for as short a time as possible and allowed to flatten gently, under a board. To remove a print that has unrolled in a tube, grasp the inner corner of the print, twist it gently toward the centre, and withdraw the print.

Keeping Work Flat

Not all prints should be rolled. Those with deep embossing or very thick ink *must* be carried (or sent) flat between boards.

STORAGE OF PRINTS

Choose proper storage for your works of art. A number of alternatives are available, depending on the size and type of works you collect, and on how often they may need to accessed. All prints should be stored carefully, taking into account the type of damage that could occur. All storage systems should be acid-free.

The storage container should be designed to provide physical support and stability to the work, while protecting its materials from adverse chemical reactions. Traditional containers—including plans chests, boxes, and portfolios—must be comfortably filled but not stuffed. Each print should at all times be kept separated from its neighbour, either by interleaving with acid-free tissue (which reduces the risk of acids from one work affecting adjacent ones) or by supporting it.

Check your stored work regularly to see that it is not deteriorating. Storage areas must be well ventilated so that air can circulate freely. The best possible environment for storage and display is a well-ventilated room with a relative humidity of around 50 percent and a temperature kept constant at around 60 degrees F (15 degrees C). Never store prints in attics or basements; keep them in a normal living space where the temperature is fairly constant. Note that if you are storing works in a bank vault, you should check out the conditions first.

Materials for Aiding Storage

First, be aware that quality archival materials for obvious reasons suffer less from the conditions listed above than do cheaper alternatives. The use of archival-quality mat boards or papers and mounting materials is a most important asset when storing and framing prints. Archival-quality boards, papers, films, and tissues are specially manufactured to protect prints (and other works) from the damaging interaction of acids and lignins found in other papers and boards; they also provide protection against migrating acidity. (See "Essential Questions on Mounting and Framing," opposite.)

Common tapes and adhesives can seriously damage prints—many tapes turn yellow with age and embrittle the paper beneath them,causing it to blister and crack. Archivally sound mounting tapes and

adhesives also are manufactured specifically to not react with the materials and chemicals in the prints, and they will not stain or bleed through the mounting boards or prints. It really does not cost much more for you to use conservation framing techniques and materials, and you will be passing on their benefits to future generations.

Portfolios

Today, portfolios are a generally used form of protection for unframed prints. Basically, a portfolio consists of two flat boards, hinged with linen or some other fabric. It has flaps at the sides that hinge inward, and are usually tied with tapes to keep the contents from falling out. Portfolios come in various sizes, based either on traditional sizes of handmade paper—Royal, Imperial, and Antiquarian—or on a metric scale (AO, A1, A2, and so on). The portfolios available in art supply shops and stores, and generally used by artists to keep all types of paper together, are usually made of wood and cardboard that have a distinctly acid content. They must be regarded as potentially dangerous to prints stored in them, and they certainly must be lined with conservation or acid-free paper or boards for long-term storage. A bookbinder or other specialist can make a custom portfolio or box for you to carry or house prints that is specially constructed from archival materials, and designed to keep dust to a minimum.

Special suites of prints are often published in portfolios designed for that purpose. These are sometimes very elaborate and contain original designs by the artist concerned. More conventional portfolios are also used for suites; they are covered in bookbinder's cloth and have the suite title and the artist's name blocked onto the cover. Such portfolios are made by bookbinders, but it is wise to check whether they are made from safe materials. The insertion of a sheet of inert plastic or acid-free paper between the prints and the back and front of the portfolio boards will give considerable protection.

Solander Boxes

Solander boxes are smaller than portfolios, rarely exceeding twenty by fifteen inches (51 by 38 cm). They are traditionally used to house smaller works on paper. They have rigid sides, usually about three

inches (75mm) deep, which open out so that prints or drawings in one half can be slid sideways into the other half with a minimum of handling. They are in general use by museums for print storage. Each print is mounted—using conservation board for the backing board and window mount—before being placed in the solander box; prints kept in this way are never directly touched by unprotected fingers. Solander boxes are available from archival suppliers or may be specially made to measure by a bookbinder.

Plans Chests

Plans chests with large, shallow drawers constitute normal storage for prints, and can be handsome pieces of furniture in their own right. The hazards of lifting large sheets of paper in and out of plans chest drawers can be avoided by resting prints on large sheets of conservation mounting board, or by hinging two of these boards together (like a portfolio) to keep prints in manageable sets. Prints should always be interleaved with acid-free tissue for added protection from one another.

ESSENTIAL QUESTIONS ON MOUNTING AND FRAMING

One of the best ways to keep a print safe is to frame it. Yet without a doubt the greatest damage to a work of art on paper—even in the enlightened nineties—occurs during mounting, matting, or framing with such commonly used materials as inexpensive wood pulp mat board, corrugated cardboard, rubber cement, animal glues, synthetic adhesives applied either wet or with heat (dry mounting) masking, transparent and double-sided adhesive tapes and sprays, and brown gummed tapes—to mention just a few. These materials share one characteristic (in addition to cheapness and convenience)—they deteriorate badly over time, damaging the artworks with which they are in contact. In Britain, it has been estimated that almost 70 percent of the repair work carried out by professional conservators is *on account of poor mounting and framing methods.* A wide range of high-quality materials is available today, making possible higher standards in mounting, and framing, and enabling the achievement of a chemically stable environment within the package of the mounted and framed work.

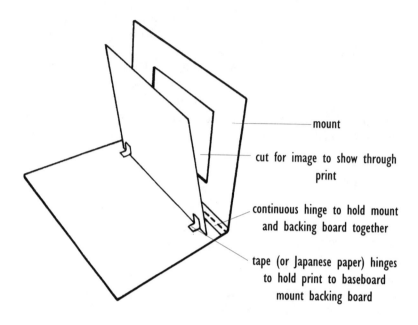

mount

cut for image to show through print

continuous hinge to hold mount and backing board together

tape (or Japanese paper) hinges to hold print to baseboard mount backing board

Mounting a print.

Margins

Margins can be defined as any area outside the plate mark of a print in intaglio, or outside the drawn or printed border in other techniques. Prints were almost invariably trimmed down to their borders or plate marks by their owners before the eighteenth century. A print trimmed to just outside the plate mark is often described as having "thread margins." In the nineteenth century, collectors began to place an "irrational" premium on margins; as a protest against this, Whistler (from about 1880) trimmed all of his prints himself, leaving only a tab for his butterfly monogram. It is traditional that the side and top margins be of equal size, with the bottom margin slightly larger.

I have set out to explain what is necessary to achieve an awareness of quality in mounting and framing by using a question-and-answer format.

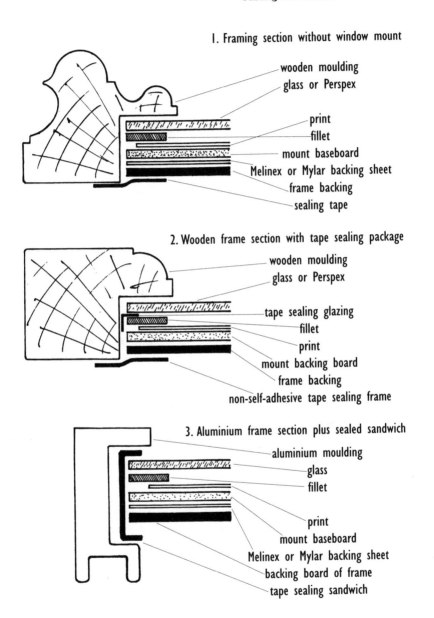

1. Framing section without window mount

wooden moulding
glass or Perspex
print
fillet
mount baseboard
Melinex or Mylar backing sheet
frame backing
sealing tape

2. Wooden frame section with tape sealing package

wooden moulding
glass or Perspex
tape sealing glazing
fillet
print
mount backing board
frame backing
non-self-adhesive tape sealing frame

3. Aluminium frame section plus sealed sandwich

aluminium moulding
glass
fillet
print
mount baseboard
Melinex or Mylar backing sheet
backing board of frame
tape sealing sandwich

Framing methods.

Q. *Why bother framing a print?*

In order to show a print in an exhibition or hang it on a wall without the risk of damage, framing is required. It is the paper that is most susceptible to damage. Some types of frames are better than others at protecting prints, but some frames can also themselves cause damage. Give careful consideration to your choice of frame.

Q. *First, what type of moulding should I choose?*

This largely depends on your own personal preference. A wide range of mouldings is manufactured from wood, MDF, metal, and plastic. When considering a wooden moulding, determine what type of wood it is made from. Tropical wood such as Ramin is widely used for making mouldings but is not harvested on a sustainable basis (that is, it has been so extensively cut that supplies are in jeopardy). Ash, oak, maple, and pine are all suitable for mouldings and are sustainable timbers. Mouldings made from MDF (medium-density fibreboard, manufactured from plantation-grown softwoods) have inherent stability, are free from knots and grain defects, are consistently straight, and do not distort or split. These can be obtained painted, veneered, and so on. The moulding should be deep enough to hold at least two 6-ply conservation boards, plus the glazing, plus the backing board, plus space for the proper securing of the back with pins or braces. The larger the picture, the heavier its moulding should be. The frame should be robust and secure at the corners. (Note that your framer should glue and pin mitered corners.)

Q. *What are the common methods of putting a print into a frame?*

There are three main options:

1. Close framing—The print is placed between a rag mounting board and a piece of glass the same size as the print; it is then fitted into the frame.

2. Float mounting—The print is placed between a rag mounting board and a piece of glass larger than the print—so that all the edges of the print are visible.

3. Window mounting—The main function of the window mount is

to keep the print from making direct contact with the glazing. The print may be placed between two pieces of rag mounting board, with the upper piece cut so that the image and a small part of the margin show through a window, or so that the image and all of the margin around it are visible through the window.

In all of the above methods, the print and the board onto which it is mounted are never stuck together completely on all four sides; nor is it appropriate to use self-adhesive tape. The print should not be stuck to the window mount—only to the backing board. The whole frame is backed by a sheet of cardboard, hardboard, chipboard, or corrugated board. Glazing protects the front of the print; moulding protects the edges. Everything is held in place by pins pushed into the back of the moulding, parallel to the backing board. Tape is stuck over the pins and the edges of the backing board where it joins the moulding, creating a sealed environment.

Q. *Which is the best of these methods?*

This depends on your personal taste, the need for longevity of the artwork, the need for temporary or permanent framing, your interest in the print's future economic worth, and the size of your budget. Float mounting is currently a popular choice, mainly for aesthetic reasons. It is also popular because many artists are making prints in which the image covers the whole area of the paper, leaving no margins, and/or they are printing on hand- or mould-made papers with a deckle edge and want this to show. Float mounting does not obscure any part of the print or paper from view.

Q. *Are there any disadvantages to float mounting prints?*

If the print has dirty margins, or if for any other reason the margins are distracting from the print, then the advantages of seeing all of the paper by floating the print become disadvantages. A method of framing, such as window mounting, that covers more of the paper is therefore more appropriate. Also, floating prints can cause the image to be pressed up against the glass of the frame (see below). Window mounting has an advantage here in that as the upper piece of cardboard in which the window is cut keeps the print just below the glass surface.

Q. *What causes a print to become wavy in a frame?*

Humidity is the amount of water vapour in a given amount of air. Britain has a damp, insular climate, as do many parts of the United States, and there is often a degree of humidity in the atmosphere. Paper is very sensitive to humidity. If the air is damp, the paper absorbs moisture and expands. When the air is drier, it in turn absorbs humidity and the paper contracts. The expansion or contraction is not even—it varies with the width and length of the paper. Mould-made papers have a "grain"—most of the fibres lie lengthwise in the direction of the paper-making machine—and thus expand far more in the width than in the length of the sheets. Handmade sheets are less affected by water vapour (because they are formed by "roughshake"—the fibres do not have a discernible alignment) as long as they are dried slowly and evenly. Paper often buckles when the print is moved from one atmosphere to another, that is, from a cool room into a warm one or vice versa; when a frame is hung over a radiator or fireplace (in this case, the edges of the print tighten, or dry out, before the centre does); if a frame is hung on a cold outside wall of a house; or if a frame is put together with a backing sheet that is slightly damp or cold, or with a print that has come from a dry atmosphere or vice versa. In the latter case, tension is caused between the two atmospheres, and cockling of the paper occurs. Also, prints that are made onto dampened paper (such as etchings, embossings, and some lithographs) and dried unevenly (or quickly) retain a tendency to wave—reflecting the uneven drying conditions.

Suggested ways of alleviating these problems can include the use of "mature" papers (for printing and mounting) wherever possible, as well as making sure that your framer allows the paper and the mounting or backing boards to acclimatise in the same atmosphere for some time before placing them in the frame. An airtight sandwich of the work into the frame helps to combat humidity problems, as does hanging and storing prints away from extremes of temperature.

Q. *How big should I make the frame?*

This is a matter of personal preference, but a print should not be folded or cut down in size in any way in order to be fitted into its frame.

Q. What problems can occur in prints that have been incorrectly framed, and how should these problems be avoided?

1. Damage to the print if it is in direct contact with the glass: If the print is allowed to touch the glass, it can stick to the glass; its ink and some of its paper can then be ripped away when the frame is dismantled. Also, if the print is touching the glass and changes in the room temperature occur frequently, the formation of condensation and moisture inside the frame can cause the paper to warp and mould to develop. If a window mount is used, the print will not touch the glass, and these problems will not occur so readily. If, however, a window mount is not suitable for other reasons, then a strip of conservation board, acid-free cardboard, wood, or plastic—called a fillet or spacer—can be inserted between the glass and the print all around the frame. This separates the glass and the print without the fillet itself being visible once the framing is complete—because it is cut to just less than the depth of the frame's moulding rebate.

2. Discolouration of the print caused by the chemical properties of the mounting board used: Commonly available mounting boards, strawboards, millboards, woods, and hardboards are not recommended to be in contact with a valuable print. They can be recognised sometimes by their buff colour, browning edges, and propensity for snapping at the corners. They are made of short-fibered wood pulp that is not chemically inert. The chemical properties of these boards cause them to absorb acid from the polluted atmosphere. This acid is then passed on to the print, causing the paper to discolour, become brittle, or even disintegrate when removed from the frame. If at all possible, use boards that are chemically neutral. Ideally, mountingboards should be made of rag (not wood pulp), and be long-fibered, chalk-loaded, and free from alum. Avoid also "rag-faced" board, in which a chemically inert paper is used on the outside but the inside is made of wood pulp. When such a board is cut, the acid from the wood pulp can bleed directly onto the image itself. Instead, three types of board are suitable for matting prints: rag board, buffered rag board, and conservation board. All of these have a neutral or alkaline pH (of 7 or above) at the time of their manufacture. As its name implies, rag board is made from cotton rags or lints, and usu-

ally has a neutral pH. Buffered rag board is made alkaline by the addition of calcium or magnesium carbonate to neutralise acidity. Conservation mounting board—also called museum, archival, or acid-free mat board—is made from wood pulp that has been both chemically purified and buffered. Buffered mat board can significantly retard the degradation of prints that were done on acidic, poor-quality papers. (pH refers to the relative acidity of a substance, on a scale from 1 to 14. Neutral is pH 7. Below this denotes acidity; above, alkalinity.)

Conservation mounting board of a minimum thickness of 1,250 microns provides a suitable barrier against harmful external substances. It can be bought in white or in a range of colours, but fade-resistant colours are preferable, as are boards whose pigments and other additives (such as adhesives used in manufacture) are "bleed resistant" in water. This will avoid the problem of dampness causing staining of a print. If a different texture or more unusual colour is desired, coloured paper may be mounted over the board, provided that an appropriate conservation glue is used. Some framers mount prints onto fabric. Care should be taken to choose a chemically inert fabric—linen, cotton, and silk are suitable, as is the specially produced, fabric-coated board that can be bought for this purpose.

3. Discolouration due to the use of unsuitable backing board: The same precautions used in selecting acid-free mounting boards should be used in selecting the backing for the print. A rag-faced board is acceptable here, however, as no cutting of the board—which would reveal its harmful, acidic centre—takes place.

4. Discolouration and tearing of prints due to the use of unsuitable glue or tape: All adhesives should be acid-free if they are to be used for framing. When sticking anything to the print, avoid brown gummed tape, Selotape, Scotch tape, masking tape, and most common glues. If used these can become brittle and cease to hold the print in place, or they can become very sticky. A dirty stain can appear where the tape holds the print to its board, and the paper can turn translucent. If the print is to be remounted, the paper can tear as the tape is removed. Glues can spread if applied too thickly.

The preferred method of securing prints and drawings into mats is with hinges. These are small strips of folded, long-fibered Japanese tis-

sue applied with purified starch. Typically, two hinges are applied at the top corners of the back of the artwork. The advantages of these hinges are that they are strong, flexible, and lightweight, with excellent aging characteristics. They also allow the paper to expand and contract freely in response to shifts in temperature and humidity. Hinges of this sort are not automatically used by framers because of the labour involved. However, in the long run, money invested in proper hinging and mounting is money well spent—especially when compared to the costs of restoration or the loss of value suffered by a damaged artwork.

It is possible to buy conservation tape, which is designed to cause none of these problems, although some people do advise that even this tape is not guaranteed to be 100 percent problem-free—it may be insoluble in water and require strong solvents for removal (easy reversibility is normally considered an archival attribute). The tapes with a water-soluble adhesive are best. Very little tape is required—only that fastening the top two corners of the print to the backing board (not to the window mount) by small, folded hinges. In this way, the print hangs from the top edge of the paper. Prints should remain as free as possible so that no stress is put upon them. Paper must be allowed to breathe with environmental conditions; if all corners (or edges) are stuck down, there is a risk that the paper will want to move and consequently crease or buckle. The tape used should always be weaker than the paper so that under any stress it is the tape and not the print that gives way and tears. Suitable glues are water soluble and nonstaining (for example, all-vegetable library paste).

Photo corners made of clear polyester film or acid-free paper are especially useful for attaching small prints; they are often preferable, because no adhesives are put directly onto the artwork.

Note that the framing industry is clearly responding to the increased demand for materials that meet conservation standards.

5. Lack of protection from the environment: Strong light causes prints to fade and paper to become brittle. Even if the most damaging of the sun's rays (ultraviolet) are filtered out by the use of a special Plexiglas (UF-3), damage can still occur. It is therefore best to avoid direct or indirect sunlight and fluorescent light. If the edge of a print is masked from light by the mount and the print is then exposed to sunlight or fluorescent light, a strip of the print is likely to become a different colour from

the rest. If a frame is not sealed at the back with tape, there is a risk that moisture and dirt could get inside the frame and cause damage, or that small insects could enter the frame and eventually die, leaving a stain. Do not use a tape to seal the frame that prevents the contents of the frame from "breathing." Brown gummed tape is suitable and widely used. A glazing strip is advisable in very polluted areas; this seals the inside of the glass and the moulding. No self-adhesive tapes are suitable. They soon cease to be sticky, especially when secured to wooden frames. Use linen or paper tapes that have animal-glue adhesives, or Japanese or European papers that use pure starch paste. Poly vinyl adhesives (PVA) should be used when a nonglass glazing is used.

You can protect against mould growth by placing inside the frame, behind the print, a sheet of tissue paper impregnated with the fungicide Topane WS (sodium ortho-phenylphenate).

Anything that touches the print, such as a sticky label or dirty hands, will, in time, leave a mark. Take great care at all times to prevent the print from becoming contaminated while it is being stored before framing. Most frame makers store work in an acid-free folder, interleaved with white acid-free tissue or neutral glassine, at room temperature and in the dark.

Q. *Are there any alternatives to using glass?*

There are various choices for glazing: glass, Perspex (sometimes called Plexiglas), and polycarbonate. Each has some advantages and disadvantages.

From an environmental standpoint, glass is a harmless and wholly inert substance and can be recycled; it is easily available at reasonable cost. (Perspex, on the other hand, is the product of a chemically based industry; it does not break down easily, and it causes problems of waste incineration, because it gives off poisonous gases when burned.) Glass does not scratch easily, but it is inflexible (and so cannot withstand torsional stress) and heavy. It is less expensive, but it can shatter and cause damage to the print. Moisture tends to condense on it, creating a risk of damage to the print. Ordinary glass also has no UV filter. Nonreflective glass is not advisable, as moisture can condense on it—which often results in mould growth. However, there are on the market several types of specialised glass that are nonreflective; some of them have UV screens inserted in an invisible sandwich. Imported from Germany (often under

trade names such as Mirrorguard) is a new and very expensive glass that has a built-in antiglare. In Britain, a superior, nonreflective glass—called Museum AR and used by many museums—cuts out ultraviolet light and is antiglare. This is another very good (but fairly expensive) alternative. Two-millimeter thick glass is normal for glazing a print.

However, some people prefer a rigid, clear acrylic commonly called Plixi, Plexiglas, or Perspex. Perspex is less likely to break than glass. It is available in larger-sized sheets than glass, and is lighter. With large frames using glass, the thickness of the glass must be increased in order for it to be sufficiently strong. This means that, to hold the glass, the thickness of the frame must also increase. If a thinner frame is aesthetically more suitable for a large work, Perspex might thus be the better choice. Some Plexiglas has an ultraviolet filter, which protects the print from fading. Polycarbonate is similar to Perspex, but does not have this UV filter. Unlike glass, Perspex is electrostatic—it can generate static electricity, especially when wiped, which in turn causes dust to stick to it. Special antistatic cloths or solutions must be used regularly to reduce the buildup of static. If the surface of the print is of a chalky nature, the static generated by Perspex can cause the particles to lift away from the paper. A sandwich of Perspex and glass is available as an alternative.

Please note that, when cleaning the glazing before assembling the frame, it is advisable to avoid those cleaning substances that contain ammonia, insecticides, or solvents, as these could eventually damage the print.

Q. *What is the best sandwich?*

After being properly hinged and mounted, the artwork is fitted in the frame. Once there, it must not come into contact with the glazing material (which has been placed in the frame first). Wherever these two touch, moisture can condense and may result in mould growth. Indeed, one of the more important functions of a mat or mount is to provide a breathing space that will accommodate any natural movement of the work on paper, and dissipate any trapped humidity. Spacers or fillet—narrow strips of mat board or plastic inserted around the perimeter of the frame and hidden from view by the "rabbet" (the lip of the moulding on which the glass rests)—can also provide space for unmatted and particularly cockled or warped papers. The remaining space between the glazing and the artwork is filled with acid-free cardboard or

polystyrene cored board. Small stainless steel or brass nails—usually called brads or glazers' points—secure the sandwich firmly against the frame. The whole of the perimeter should then be sealed with gummed tape to prevent dust penetration.

Q. *What is the difference between conservation and museum board?*

Actually, there are three types of mounting board:

1. Standard board, which is made from unpurified wood pulp. This contains lignin, which is dangerous—it generates acid as the board ages, and this acid can then seep through the board (especially if a window for the print has been cut, or the board has been used as a backing). Some boards are buffered with calcium carbonate to slow down the increase of acidity, but these are not of high enough quality to use in quality framing.

2. Conservation board, which has been chemically treated to re-move the lignin and leave the pH value at around 8. Again, it is buffered with calcium carbonate to produce alkalinity.

3. Museum board, which is made from cotton fibre and is available both as a solid plate board and as a paper-faced board (as is conservation board). Most museum boards are also buffered with $CaCo_3$. Most conservators prefer to use museum board because it is an "all rag" board and known for its longevity.

Q. *If I do not want the print to stay in the frame permanently, is there a suitable type of temporary frame?*

The are many "quick-change" framing systems. These have backs that are easily removed, with hinged or bendable fastenings. Minimum damage is thus done to the frame as its back is removed. This type of framing also has the advantage of allowing access to the glass so that moisture, mould, or dust can be easily cleaned out.

Q. *Are clip-frames recommended?*

No! This is because they give scarcely any protection against the problems described above. The print is held up against the glass, which is vulnerable to breakage due to the lack of moulding. Also, the edges

of these frames are wide open to entry by dust, dirt, and so on. Many galleries and museums do not handle works in clip-frames.

Q. *What sort of fittings do I attach to the frame for hanging?*

This depends on your preference. Most types of fixtures are attached to the back of the moulding. The frame should not be under any strain when hanging, so the string, cord, wire should be loosely tensioned. On smaller frames, nylon cord is normal; it tends to be much stronger than wire, but it stretches when used with heavier frames. Replace rusty wires with new ones of braided or twisted steel. Wire may snap when used with very heavy frames, and it can fail in moist conditions due to electrolysis between the wire and the hanging fittings. There is a plastic-coated wire available that is much safer. Chains can be used for really large or heavy frames.

A thin wooden frame around a large print presents a hanging problem, as the frame will pull away from the glass. This can be avoided by using a metal frame, or by using the "W" method of stringing at the back of the frame instead of the horizontal-line. Pads or buffers, often made of cork, should be placed at the back bottom corners of the frame to allow circulation of air over the back of the picture once it is hung.

Q. *If I tear the print when framing or reframing it, what should I do?*

If any damage occurs to the print, seek expert help. Do not tear the borders of the print down if you have accidentally damaged them—the work should be kept as close to its original condition as possible. Seek expert help.

REPAIR IF DAMAGE OCCURS

In the first place, when buying a print, it is prudent to ask for a written declaration that includes a reference to the print's condition. For instance, if you have bought a print in which a collaged item is attached by means of Selotape, then you can expect damage to occur eventually. When you are buying from a saleroom, almost all sale catalogues declare any damage to the print or, alternatively, indicate if it is perfect or not. The absence of the word *perfect* can give rise to unpleasant wrangling in the case of a subsequent complaint.

Each artwork is made up of a number of unique components constructed in a specific way. With its creation, the work is subjected to all of the various stresses outlined above—environmental factors, aging, handling, and so on. Damage almost always occurs accidentally, often so slowly that the owner of the work has no idea what is happening—except in the case of an emergency, such as a fire or flood.

The following general points might be useful:

1. Hasty removal of old mounts is likely to increase tearing or abrasion of the work. If they are well and truly stuck, consult a professional.

2. Distortions in the paper can be relaxed by spraying or washing with water. Soaking in a bath of water can also disperse concentrated discolourations. Consult a professional. Please note that this method can be disastrous if used without adequate knowledge.

3. To reduce grime deposits on borders, dust with a soft brush or rub a little with a soft eraser. You must take care not to damage the surface fibres. Consult a professional.

4. In order to reduce foxing or stains, the paper may need bleaching. Bleaching exposes the already damaged area to more chemical stress and is not recommended except in extreme cases. Consult a professional.

5. Light creases can be removed by dampening the work slightly and drying the creased area under pressure. Consult a professional.

6. Small rips and tears can be mended. A starch, rice, or wheat flour, mixed with water to form a paste, is applied to a small strip of thin Japanese Kozo paper; this is then pressed onto the back of the torn area. If the edges of the mending paper are torn, they give a soft edge to the mend. Consult a professional.

7. A paper that is extremely old or desiccated, or has many tears, may need an overall support. A backing of Kozo paper, applied over the whole area with a thin rice or starch paste, will help the work. Consult a professional.

8. Papers that need deacidification—that is, the introduction of an alkaline buffer—should be handed to a specialist. Calcium and mag-

nesium carbonate are the most likely buffering agents, but this work needs to be done by a conservationist with testing equipment.

A print that is not too badly damaged can be satisfactorily repaired by a qualified restorer, who may even be able to give it back some of its original characteristics. Such a work must be of considerable value, however, because the expense of repair can be great. If your prints have been damaged accidentally, or if they have been subject to fire or flood damage, the best course of action is to seek expert help immediately so as not to jeopardise any repair that can be made.

CONSERVATION AND RESTORATION

Conservation—The treatment of works of art or materials to stabilise them chemically or strengthen them physically, sustaining their survival as long as possible.

Many of the works of professional artists are bought by museums and collectors. The vast proliferation of works on paper collected by museums in the twentieth century has meant that curators and advisers have had to search for methods of preserving works rather more urgently than in the past; the unique properties of paper have also led to the introduction of paper specialists in the conservation and restoration fields. A distinction can be made between the "archival" conservator and the conservator of "works of art on paper." These professionals approach their work from differing points of view: The archivist is concerned with strength, legibility, and permanence; the conservator of artwork is concerned not only with the paper surface, but also with the integration of the image and paper that creates the visual effect—a quality that must not be lost if the paper support or even the paint or ink has been damaged. Conservation is a scientifically informed discipline. Practitioners in the field of conservation study the circumstances that may lengthen or shorten the life of a print or work on paper.

The restorer or conservator undertakes to restore a damaged work. The practice of restoration has its roots in antiquity. Repair or disguise of past damage was usually carried out by artisans or artists experienced in making the types of objects they repaired; it was not until the early nine-

teenth century that advances in science led to a new understanding of the material world, one that supported the development of a number of new professions in repair of works of art. Specialists in science, art history, and restoration began to be trained to protect and prolong the lives of treasured works. By the early twentieth century, large institutions had begun to found their own restoration departments—Germany in 1888, Britain in 1921, France and the United States in 1930. Increasing concern about caring for collections has helped initiate the founding of worldwide groups to promote training and research in conservation.

One of the fundamental contemporary rules of conservation is Above all, do no harm. Another principle of conservation is that every treatment should be reversible. This must be understood within the context of conservation because some treatments are by their nature irreversible. Even established treatments are not always appropriate. When considering the best treatment for your print, weigh the following factors, all of which may affect your decision:

1. The historical significance and documentary value of the work.

2. Its aesthetic considerations.

3. Your own personal experience of the work.

4. Its place in the contemporary cultural climate.

5. Uncontrollable outside influences such as geography, climate, or location.

Planning of the repair of damage is essential. In this particular age, minimal treatment is often preferred (which leaves a work closer to its original appearance, except for its inherent change over the years). Whether changes introduced by conservationists should be left depends on your print's history and use. The restoration of an aged or damaged artifact to its original state lies outside our reach, since no one can now bear witness to its original appearance.

It is wise to obtain professional advice when a print has become damaged. In many countries there are professional bodies of which conservators are members; if this is not the case, then there will be Code of Ethics or Standards of Practice documents. To locate a qualified restorer or conservator, seek a referral from your print dealer or gallery, your

framer, your local library, a local or national art museum, an archival supplier, a local conservation group, a local history or archaeological group, and so on. Discuss your problem with your conservator carefully before embarking into conservation itself. An examination will be necessary; the damage to the print will be identified, and recommendations for correcting the problem will be given, together with an estimate of cost and repair time. It may be that the restorer will calculate his fee not according to the work he does or to a fixed tariff, but rather on the basis of what the value of the print might have been before and what it might be after repair; in other words, the restorer may ask for a kind of share in the profit that his client could derive from the repair. Properly executed restoration on a valuable print might cost its owner 10 to 20 percent of the price he paid for it. When you have decided to go ahead, descriptions of the actual treatment carried out and the names of the materials employed are necessary, as are photographic documentation of the work and suggestions for future care.

ARCHIVAL GLOSSARY

Acid In chemistry, a substance capable of forming hydrogen ions when dissolved in water. Acids can weaken cellulose in paper, board, and cloth, leading to embrittlement.

Acid-free A paper that is free from any acid content or content of other substances likely to have a detrimental effect on the paper or its longevity. In chemistry, the term is applied to materials that have a pH of 7 or higher. Sometimes this term is used incorrectly as a synonym for *alkaline* or *buffered*. Acid-free materials can be produced from virtually any cellulose fibre source (cotton and wood, among others) if measures are taken during the manufacture to eliminate active acid from the pulp. However free of acid a paper or board may be at the time of manufacture, though, over time the presence of residual chlorine from bleaching, aluminium sulfate from sizing, or pollutants in the atmosphere may lead to the formation of acids—unless the paper has been buffered with an alkaline substance.

Acid migration The transfer of acid from an acidic material to a less acidic or pH-neutral material.

Alkaline Alkaline substances are those with a pH of over 7. They may be added to materials to neutralise acids, or as an alkaline buffer for the purpose of counteracting acid that may form in the future. While a number of chemicals may be used to form buffers, most common are magnesium carbonate and calcium carbonate.

Alpha cellulose A form of cellulose derived from cotton. The presence of alpha cellulose in paper or board is one indication of its stability and longevity.

Archival A term that suggests that a material or product is permanent, durable, or chemically stable, and can therefore be used for preservation purposes.

Buffering agent Also called alkaline reserve, this is an alkaline substance, usually calcium or magnesium carbonate, purposefully added to paper to help protect it from acidity in the environment.

Conservation The treatment of works of art or materials to stabilise them chemically or strengthen them physically, sustaining their survival as long as possible.

Deacidification A common term for a chemical treatment that neutralises acid in a material such as paper.

Humidity The quantity of water vapour in the atmosphere, measured by a hygrometer.

Lignin A component of the cell walls of plants that occurs naturally along with cellulose; it rejects water and resists bonding, therefore it must be removed from fibres before the papermaking process. Lignin is largely responsible for the strength and rigidity of plants, but its presence in paper and board is believed to contribute to chemical degradation.

Neutral Having a pH of 7; neither acid nor alkaline.

Permanence The ability of a material to resist chemical deterioration. Permanent paper usually refers to a durable, alkaline paper that is man-

ufactured according to a certain standard. Its permanence nevertheless depends on proper storage conditions.

pH In chemistry, pH is the measure of the concentration of hydrogen ions in a solution—which is a measure of its acidity or alkalinity. The pH scale runs from 1 to 14. A pH of 7 is neutral; numbers below 7 indicate increasing acidity, with 1 being most acid. Numbers above 7 indicate increasing alkalinity, with 14 being most alkaline. Paper below pH 5 is considered acidic.

Preservation Activities associated with maintaining library, archival, or museum materials for use, either in their original condition or in some other format. *Preservation* is a broader term than *conservation*.

Portfolio of
Contemporary Prints

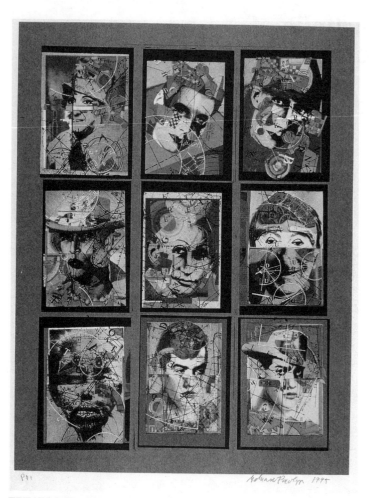

EDUARDO PAOLOZZI

NINE HEADS

Monotype, 1995. Image size: 58 x 45cm. Paper size: 71 x 56cm.

A forty-two-color screenprint, printed on Saunders Waterford, 300 gsm. This print is a printer's proof from outside an edition of forty unique items. Printed by Gresham Studio Ltd. Published by Gresham Studio Ltd. and the artist. The sheet carries the studio chop mark. Permission for reproduction from Gresham Studio Ltd. and the artist. Photo by and courtesy Gresham Studio Ltd.

RICHARD LONG

A CLIMB UP THE AVON GORGE

Screenprint, 1995. Image and paper size: 67 x 56cm.

A six-color screenprint on Lana Aquarelle H.P., 300gsm. Printed by Gresham Studio Ltd. Published by Gresham Studio Ltd. and the artist. The sheet carries the studio chop mark. Permission for reproduction from Gresham Studio Ltd. Photo by and courtesy Gresham Studio Ltd.

ANA MARIA PACHECO

TERRA IGNOTA 4

Drypoint, 1994. Plate size: 32.5 x 25.4cm. Paper size: 57 x 46.5cm.

Published by Pratt Contemporary Art, Kent. One of a series of ten drypoints. Printed in an edition of twenty-five plus two printer's proofs and two artist's proofs. Printed on Somerset T.P., 300 gsm. Chop marked by the studio. Permission for reproduction from Pratt Contemporary Art and the artist. Photo by and courtesy Pratt Contemporary Art.

EDUARDO PAOLOZZI

LES CHANTS MALDOROR DUCASSE

Etching, individually hand coloured by the artist, 1992. Image size: 33 x 50.8 cm. Paper size: 56 x 76.2 cm.

This print is from a portfolio, *Six Artists 1992*, published by the Royal College of Art, Printmaking Department, London, through the goodwill of the artist and the College to raise funds to help students make better use of the Printmaking Course. It was published in April 1992, in an edition of fifty copies plus ten proofs numbered in Roman numerals. Printed by Michael Agnew, proofed by Alan Smith. Printed on Somerset Satin, 300 gsm. Permission for reproduction from Royal College of Art, Printmaking Department and the artist. Photo by Frank Thurston and courtesy Royal College of Art, Printmaking Department, London.

TONY WILSON

KNOW THYSELF (PART OF THE THIRD OF MAY SERIES)

Ink-jet print, 1995. Image size: 48 x 68cm. Paper size: 70 x 100cm.

This is a computer print in which the image was generated on Photoshop 3 using Layers Program and 3D Imagine. It was output on a Nova Jet 3 colour ink-jet printer. Edition of fifty copies. Published by the artist. The paper is Rivoli Blanc, 300 gsm. Permission for reproduction from the artist. Photo by and courtesy the artist.

JIM DINE

WHITE OWL (FOR ALAN)

Intaglio on cardboard plate, 1994. Overall paper size: 149.3 x 77.5cm.

This was printed in an edition of twenty copies with ten artist's proofs at the Spring Street Workshop, New York. Copublished and distributed exclusively by Pace Editions, Inc., New York, and the Alan Cristea Gallery, London. Permission for reproduction from the Alan Cristea Gallery, London. Photo by Rodney Todd-White and courtesy the Alan Cristea Gallery, London.

MIMMO PALADINO

5. PAESAGGIO CON J-P

Etching and Aquatint, 1994. Paper size: 56 x 76cm.

This is a print from *Paesaggi*, 1994. One of a portfolio of ten prints, pre-
sented in a cloth-bound portfolio. Proofed and editioned at Laboratorio
d'Arte Grafica di Modena, Italy, in an edition of fifty with eight artist's proofs.
Published by Waddington Graphics and distributed exclusively by the Alan
Cristea Gallery, London. Permission for reproduction from the Alan Cristea
Gallery, London. Photo by Rodney Todd-White and courtesy the Alan
Cristea Gallery, London.

PATRICK CAULFIELD

WALL LAMP

Screenprint, 1994. Image/paper size: 76.2 x 55.9cm.

This print is from a portfolio entitled *Six Artists 1994*, published by the Royal College of Art, Printmaking Department, London, through the goodwill of the artist and the College to raise funds to help students make better use of the Printmaking Course. It was published in 1994 in an edition of fifty copies plus ten proofs numbered in Roman numerals. Proofed and printed by Bob Tipper. Printed on Saunders Waterford Rough, 300 gsm. Permission for reproduction from Royal College of Art, Printmaking Department and the artist. Photo by Frank Thurston and courtesy Royal College of Art, Printmaking Department.

HOWARD HODGKIN

VENICE, NIGHT

Hand-painted dyptych with etching, aquatint, carborundum, 1995. Overall size: 159 x 195cm.

This print was printed from five plates, and proofed and editioned by the 107 Workshop, Wiltshire. It is published and distributed exclusively by the Alan Cristea Gallery, London, in an edition of thirty plus ten artist's proofs. Permission for reproduction from the Alan Cristea Gallery, London. Photo by Rodney Todd-White and courtesy the Alan Cristea Gallery, London.

LUCIAN FREUD

RECLINING FIGURE

Etching, 1994. Image size: 17 x 23.6cm. Paper size: 35 x 41.5cm.

This etching is the most recently published etching of Leigh Bowery, who died shortly after its completion. (He was one of Freud's most popular models of recent years.) This print is an artist's proof aside from the edition of forty. Proofed and printed by Marc Balakjian of Studio Prints, London. Published by Matthew Marks, New York. (Catalogue reference Craig Hartley—"The Etchings of Lucian Freud—A *Catalogue Raisonné* 1946–1995.") Permission for reproduction from Mathew Marks Gallery and the artist. Photo by Prudence Cummings Assoc. Ltd. and courtesy Marlborough Graphics Ltd., London.

FRANK AUERBACH

RUTH

Etching, 1994. Image size: 25 x 20cm. Paper size: 38 x 32cm.

This was Auerbach's first etching since 1990 and related to drawings and paintings of the same sitter. Auerbach often uses a dart or a screwdriver for his "needle"—the latter, probably, in this case. A two-plate etching printed in black and grey, proofed and printed by Mark Balakjian of Studio Prints, London, in an edition of thirty prints. Permission for reproduction from Marlborough Graphics Ltd., London, and the artist. Photo by and courtesy Marlborough Graphics Ltd., London.

KEN KIFF

MASTER OF ST. GILES

Woodcut, 1994. Image size: 35.5 x 29.5cm. Paper size: 78.5 x 60.5cm.

A coloured woodcut from one block, proofed and printed by Josephine Briggs. It was made while Kiff was Associate Artist at the National Gallery. Printed on Japon paper in an edition of thirty-five. Permission for reproduction from Marlborough Graphics Ltd., London, and the artist. Photo by and courtesy Marlborough Graphics Ltd., London.

GRENVILLE DAVEY

EYE (PAIR A)

Screenprints, 1993. Image and paper size: 72 x 83.5cm.

These prints are part of a series of six prints in three pairs whose images were originated through computer animation. The technique involved prints being fed into the Kodak Photo-Disk System and transferred to Mac's IIFx System. The images were computer analysed with Acute Focussing and Gauzian Blur techniques. The information was digitalized and used to generate colour separations, from which screenprints were made. *Pair A* is fourteen screenprinted colours with varnish. Printed by Coriander (London) Ltd., with computer work by After Image, London, in forty sets numbered one through forty plus ten proofs. Released either as sets or in pairs. Published and distributed exclusively by Charles Booth-Clibborn and The Paragon Press, London. Permission for reproduction from Charles Booth-Clibborn, The Paragon Press, London, and the artist. Photo by and courtesy Charles Booth-Clibborn and The Paragon Press, London.

PAULA REGO

ROCK A BYE BABY

Etching/Aquatint, 1994. Image size: 22.5 x 21cm. Paper size: 52 x 38cm.

From the series of *Nursery Rhyme* etchings. Proofed and printed by Paul Coldwell of the Culford Press, London, in an edition of fifty copies. Permission for reproduction from Marlborough Graphics Ltd. and the artist. Photo by and courtesy Marlborough Graphics Ltd., London.

BILL WOODROW

GREENLEAF

Etching, 1992. Image size: 60.3 x 50.3cm. Paper size: 68.7 x 76cm.

Part of a series of five etchings plus title page and colophon, in a portfolio of the same name, in brown and black cloth with "hair-on" insertions. From a story by American writer Flannery O'Connor. Principally soft-ground etching, with some hard-ground etching, aquatint, and spitbite. Each printed from single copperplates. Proofed by Pete Kosowicz and printed by same and Mike Linfield at the Hope Sufferance Press, London, in an edition of thirty-five sets plus six proofs and one B.A.T.; the first twenty-five sets were issued in portfolio form. Published and distributed exclusively by Charles Booth-Clibborn and The Paragon Press, London. Permission for reproduction from Charles Booth-Clibborn, The Paragon Press, London, and the artist. Photo by and courtesy Charles Booth-Clibborn and The Paragon Press, London.

IAN McKEEVER

HARTGROVE

Woodcut, 1993. Size: 89 x 68.5cm.

This is one of a series of ten woodcuts from the portfolio entitled *Hartgrove*. The woodcuts are made from plywood and shuttering ply, and printed on an etching press. The whole is editioned in thirty-five sets plus five proofs. The first twenty sets are issued as portfolios, the remaining fifteen are split up and released separately. Printed on BFK Rives, 300 gsm, by Hugh Stoneman and Michael Ward of the Print Centre, London. (Catalogue reference Contemporary British Art in Print—"The Publications of Charles Booth-Clibborn and His Imprint The Paragon Press.") Published and distributed exclusively by Charles Booth-Clibborn and The Paragon Press, London. Permission for reproduction from Charles Booth-Clibborn, The Paragon Press, London, and the artist. Photo by and courtesy Charles Booth-Clibborn and The Paragon Press, London.

BRUCE McLEAN

ON THE BALL (FROM THE FOOTBALLER SERIES)

Screenprint, 1991. Paper size: 120 x 92cm.

This print is a thirteen-color screenprint, each stencil made by hand by the artist. It is printed on Arches, 300 gsm, in an edition of fifty with no proofs. It is part of a triptych published and printed by Coriander Studio Ltd., London. Permission for reproduction from Coriander Studio Ltd., London. Photo by and courtesy Coriander Studio Ltd., London.

DAVID HOCKNEY

EINE (PART 1)

Lithograph, 1991. Image size: 123.2 x 90.9cm.

This print is an original fifteen-color lithograph, printed from thirteen aluminum plates. Printed and published by Tyler Graphics Ltd. Permission for reproduction from the David Hockney No. 1 U.S. Trust. Photo by and courtesy Tyler Graphics, New York.

FRANK STELLA

SWOONARIE (from the Imaginary Places series)

Etching, 1995. Image size: 106.7 x 132.1cm.

Printed and published by Tyler Graphics Ltd.
© copyright Frank Stella/Tyler Graphics Ltd. 1995
For print details, please see the documentation sheet on page 79.

ROBERT MOTHERWELL

BLACK CATHEDRAL

Lithograph, 1991. Image size: 170.2 x 119.4cm.

This is an original seven-color lithograph, including two pulp colors and one dye color, printed from four aluminum plates. Printed and published by Tyler Graphics Ltd. Permission for reproduction from Dedalus Foundation, Inc. Photo by and courtesy Tyler Graphics, New York.

Bibliography

Bachmann, Konstanze. *Conservation Concerns: A Guide for Collectors and Curators.* Washington: Smithsonian Institute.

Brunner, Felix. *A Handbook of Reproduction Processes.* Teufen, 1962.

Castlemann, Riva. *Modern Art in Prints.* New York: Museum of Modern Art, 1973.

_____. *Printed Art: A Review of Two Decades.* New York: Museum of Modern Art, 1980.

_____. *Prints of the Twentieth Century, a History.* London: Thames & Hudson, 1976.

_____. *Technics and Creativity.* New York: Museum of Modern Art, 1971.

Challis, Tim. *Printsafe: A Guide to Safe, Healthy and Green Printmaking.* London: estamp, 1990.

Clapp, Anne F. *Curatorial Works of Art on Paper: Basic Procedures for Paper Preservation,* 4th ed., rev. New York: Lyons & Burford, 1987.

Conseil, Québécois de L'estampe. *A Code of Ethics for the Original Print.* Quebec: 1990.

Crawford, William. *The Keepers of Light: A History and Working Guide to Early Photographic Processes.* New York: Morgan and Morgan, 1979.

Dollof, F. W. and Roy Perkinson. *How to Care for Works of Art on Paper.* Boston: Museum of Fine Art, 1972.

Eichenberg, Fritz. *The Art of the Print: Masterpieces, History, Techniques.* London: Thames & Hudson, 1976.

Gascoigne, Bamber. *How To Identify Prints.* London: Thames & Hudson, 1986.

Gilmour, Pat. *Ken Tyler, Master Printer.* New York: Hudson Hills/Australian National Gallery, 1986.

_____. *The Mechanised Image* exhibition catalogue, London: Arts Council, 1978.

_____. *Understanding Prints: A Contemporary Guide.* London: Waddington Galleries, 1979.

Goldman, Paul. *Looking at Prints, Drawings and Watercolours: A Guide to Technical Terms.* London: The British Museum, 1988.

Greenfield, Jane. *The Care of Fine Books.* New York: Lyons & Burford, 1988.

Griffiths, Anthony. *Prints and Printmaking: An Introduction to the History and Techniques.* London: British Museum Publications, Ltd., 1980.

Hayter, S. W. *About Prints.* London: Oxford University Press, 1949.

_____. *New Ways of Gravure*. London: Oxford University Press, 1949.

Heller, Jules. *Printmaking Today*. New York: Holt, Reinhart & Winston, 1958, reprinted 1972.

Hunter, Dard. *Papermaking: The History and Technique of an Ancient Craft*. New York: Dover, 1978.

Ivens, W. M. Jr. *How Prints Look*. New York: Metropolitan Museum, 1943.

_____. *Prints and Visual Communications*. Cambridge, Mass., 1953.

Karshan, D. *American Printmaking*. Washington: Smithsonian Institute, 1969.

Mann, Felix. *150 Years of Artists' Lithographs*. London: Heinemann, 1953.

McCann, Michael. *Health Hazards Manual for Artists*, rev. and enl. New York: Lyons & Burford, 1985.

Newton, Charles. *Photography in Printmaking*. London: Victoria and Albert Museum, 1979.

Peterdi, Gabor. *Printmaking*. New York, London: Macmillan, 1959, reprinted 1980.

Plenderleith, H. J. and A. E. A. Werner. *The Conservation of Antiques and Works of Art*. Oxford: Oxford University Press, 1971.

Rempel, Siegfried. *The Care of Photographs*. New York: Lyons & Burford, 1987.

Rosen, Randy. *Prints, The Facts and Fun of Collecting*. New York: Dutton, 1978.

Ross, John, Clare Romano, and Tim Ross. *The Complete Printmaker: Techniques, Traditions, Innovations*. New York: The Free Press, 1972/1990.

Saff, Donald and Deli Sacilotto. *Printmaking: History and Process*. New York: Holt, Reinhart & Winston, 1978.

Schultz, Arthur, Chairman, National Committee to Save America's Cultural Collections. *Caring for Your Collections: Preserving and Protecting Your Art and Other Collectibles*. New York: Harry N. Abrams, 1992.

Simmons, Rosemary. *Collecting Original Prints*. London: Quiller Press in association with Christie's Fine Art, 1980.

Steinberg, Saul. *Five Hundred Years of Printing*. London: Penguin, 1955.

Turner, Silvie. *About Prints: A Guide for Artist Printmakers*. London: estamp, 1994.

_____. *British Printmaking Studios*. London: estamp, 1992..

_____. *Facing the Page: British Artists Books, A Guide 1983-93*. London: estamp, 1993.

_____. *Handmade Paper Today: A Worldwide Survey of Mills, Papers and Techniques*. London: Lund Humphries, 1983.

_____. *A Printmaker's Handbook*. London: estamp, 1989.

_____. *Which Paper?* London: estamp, 1991.

Zigrosser, Carl. *Prints and Their Creators: A World History*. New York: Crown Publishers, 1936, revised edition 1974.

Zigrosser, Carl and Christa M. Gaehde. *A Guide to Collecting and Care of Original Prints*. New York: Crown Publishers, 1966.

Index

(Bolded items indicate printmaking techniques.)